VISUAL EXPLORER GUIDE

AMSTERDAM

VISUAL EXPLORER GUIDE
AMSTERDAM

CLAUDIA MARTIN

amber
BOOKS

First published in 2025

Copyright © 2025 Amber Books Ltd

All rights reserved. No part of this publication may be reproduced, stored in a retrieval system, or transmitted in any form or by any means, electronic, mechanical, photocopying, recording, or otherwise, without prior written permission of the copyright holder.

Published by
Amber Books Ltd
United House
North Road
London
N7 9DP
United Kingdom
www.amberbooks.co.uk
Facebook: amberbooks
YouTube: amberbooksltd
Instagram: amberbooksltd
X(Twitter): @amberbooks

Project Editor: Anna Brownbridge
Designer: Keren Harragan
Picture Research: Adam Gnych

ISBN: 978-1-83886-485-9

Printed in China

Contents

Introduction	6
Neighbourhoods and Spaces	8
Landmarks and Museums	78
Shopping and Restaurants	130
Entertainment and Nightlife	160
Transport	192
PICTURE CREDITS	224

Introduction

For much of human history, the site that became Amsterdam was a marsh where the River Amstel met the tidal flats of the IJ. Around a thousand years ago, farmers began to drain this land. The fortunes of the would-be settlement picked up in the 1270s when the Amstel was dammed near the current Dam Square, linking both sides of the river and leading to the name Amestelledamme. By the 14th century, the town was flourishing due to trade with northern Europe in goods such as herring, grain and timber. Yet the city's Golden Age was in the 17th century, when it became the wealthiest in Europe thanks to its cargo ships, which sailed as far as North America, Africa, Indonesia, India and Brazil. It was now that the canals of the Grachtengordel (Canal Belt) were dug to aid the transport of goods from the harbour. The canals were lined with tall houses, their gables bearing a hook and pulley for winching goods into the roof area. To disguise or celebrate this function, gables were fancifully ornamented, leading to the cricked necks of every visitor to the city then and now.

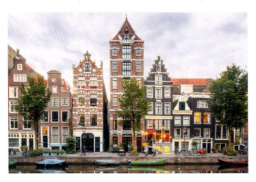

ABOVE:
Herengracht, Grachtengordel
In the 17th century, buildings were taxed on the width of their canal frontage, leading to tall, narrow homes.

OPPOSITE:
Sluishuis, IJburg
Boats can sail under this 21st-century apartment block, which echoes the gables of the Grachtengordel.

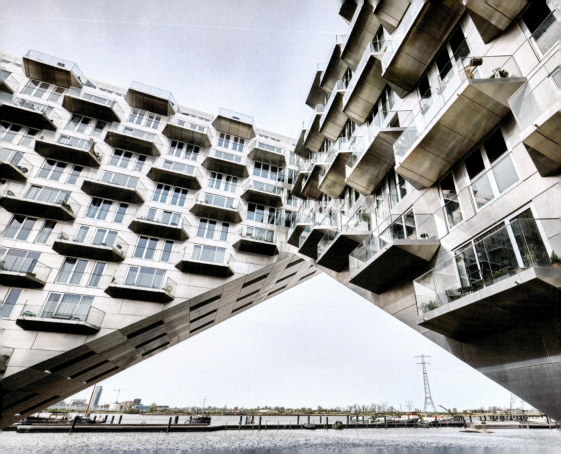

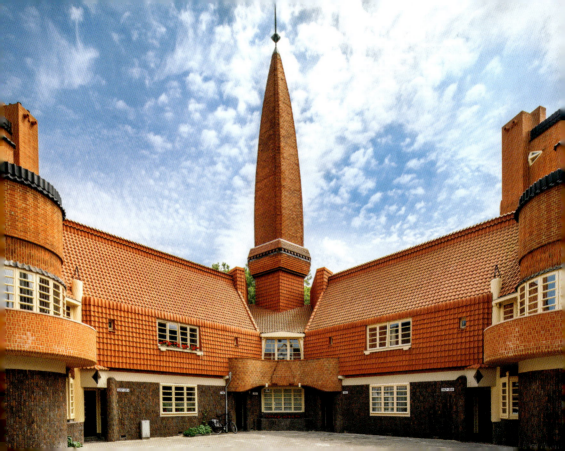

Neighbourhoods & Spaces

Amsterdam is a city of contrasting neighbourhoods and surprising spaces. If asked to picture Amsterdam, most people will imagine the gabled homes, bright canal boats and graceful bridges of the 17th-century canal belt, known as the Grachtengordel. Few people will picture the postmodern architecture, floating homes and bold bridges of the eastern docklands and islands. Most visitors to the city never set foot in the southern Zuidas business district, its jagged buildings puncturing the polite skyline. Perhaps even fewer walk the streets of the western Spaarndammerbuurt neighbourhood, where architects of the early 20th-century Amsterdam School left their mark with ornate social housing.

If asked what they are searching for, many visitors to Amsterdam will mention the coffeeshops, brown cafés and red-lit windows of the crowded old town, often called the Centrum. Fewer will mention the parks and elegant shopping streets of the well-heeled De Plantage and Oud-Zuid districts. Fewer still will mention the *hofjes* that are hidden behind the busy streets of the old centre and the characterful Jordaan and Jodenbuurt neighbourhoods. In these old almshouse courtyards, a few steps and a world away from the 21st-century city, the only sound may be a cooing pigeon. In these secret spaces, it is possible to imagine that merchants are still unloading porcelain, cinnamon and silk on the Damrak.

OPPOSITE:
Het Schip, Spaarndammerbuurt
The Spaarndammerbuurt district has many early 20th-century buildings in the style of the Amsterdam School. Michel de Klerk's apartment building showcases the movement's brick construction and rounded forms.

RIGHT:
Durgerdam
This village is around 7 km (4 miles) east of the city centre, on the shore of the IJmeer. Clapboard fishermen's cottages cluster around a 17th-century church, while nearby the marsh is home to avocets and godwits.

OVERLEAF:
Waterfront
The IJ, formerly a bay, forms Amsterdam's waterfront, which ranges from postindustrial to defiantly and profitably industrial. To the west, the IJ is connected to the North Sea Canal, while to the east it meets the IJmeer.

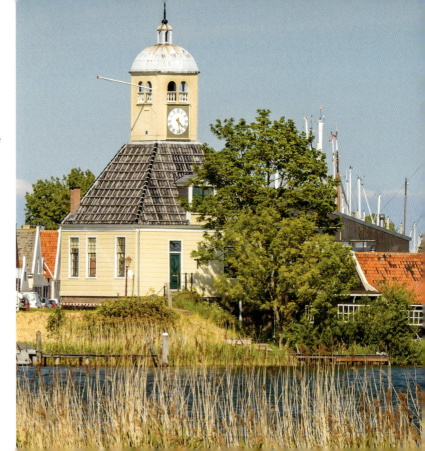

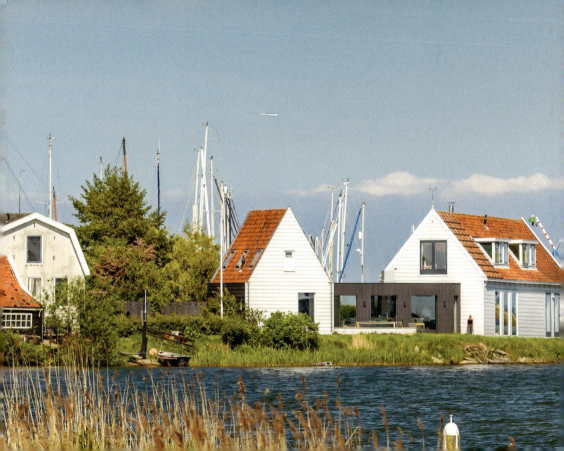

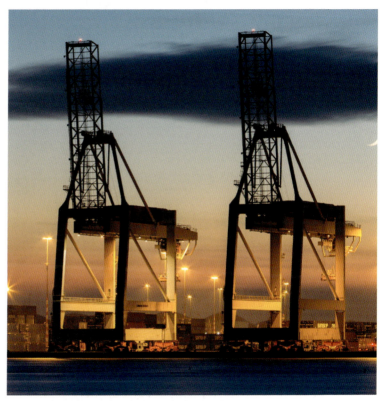

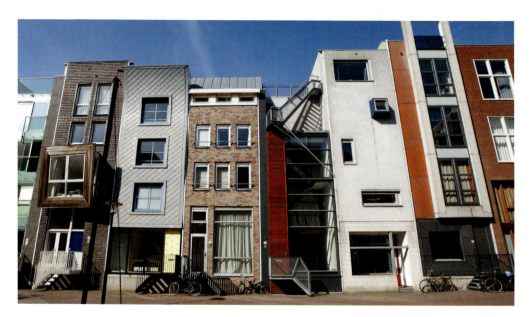

ABOVE:
Java Eiland, Oostelijk Havengebied
Created in the 19th century with dredged soil, this dockland peninsula was rejuvenated in the 1990s by a plan created by postmodern architect Sjoerd Soeters.

OPPOSITE:
Vuurtoreneiland, IJmeer
Around 7 km (4 miles) east of the city centre, 'Lighthouse Island' is accessible only by boat. It is home to a restaurant, hotel and Amsterdam's only lighthouse.

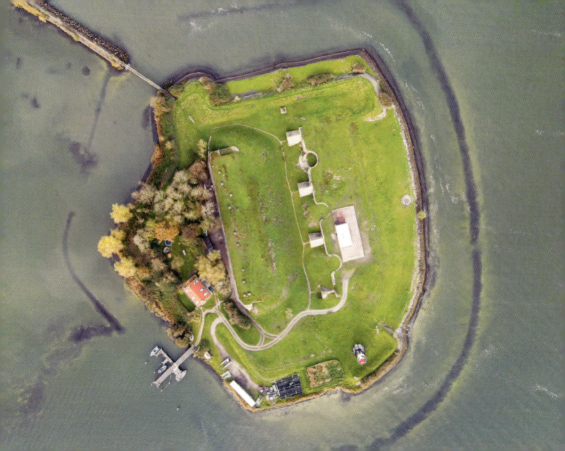

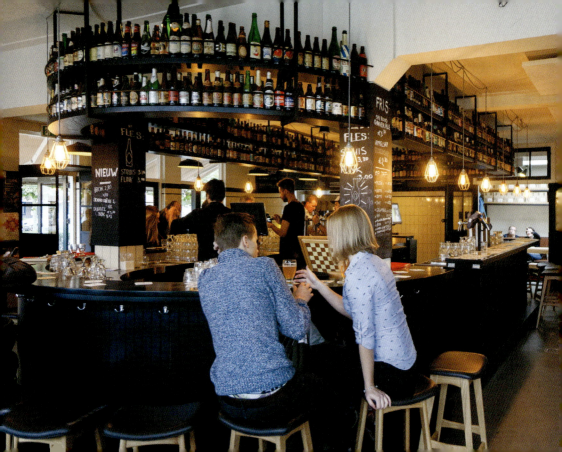

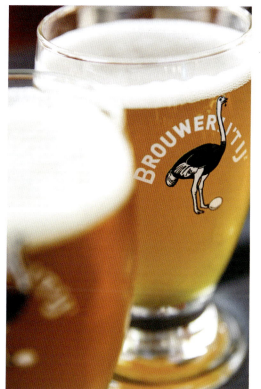

BOTH PHOTOGRAPHS:
Brouwerij 't IJ, Kadijken
Near the bridge to the eastern islands is the IJ Brewery, which was founded in 1985 by musician Kasper Peterson. Once dominated by shipping and industry, the Kadijken neighbourhood is now residential, with reminders of its past given by the many converted warehouses.

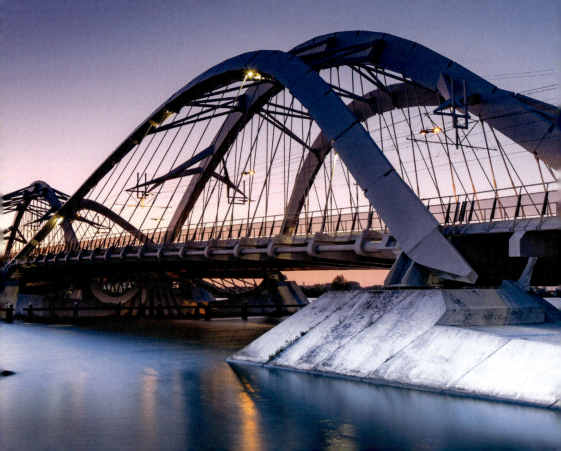

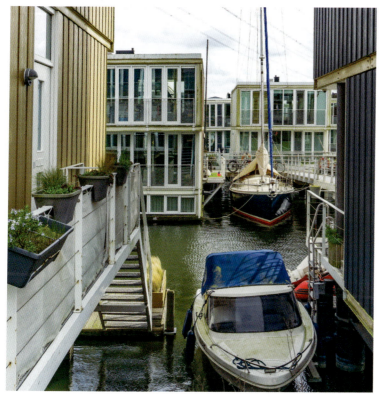

BOTH PHOTOGRAPHS:
IJburg
Built in 2001, the Enneüs Heerma Bridge (far left), connects Zeeburgereiland with Steigereiland in the IJburg neighbourhood (left). Constructed on seven artificial islands to the east of the city centre, the redeveloped zone will have 45,000 residents when complete. Whole neighbourhoods are composed of floating homes, with jetties instead of streets.

Bloemenmarkt, Grachtengordel

In the southern canal belt, on the Singel, is the world's only floating flower market. Founded in 1862, the market still has stalls selling seeds, bulbs and cut flowers, but mainly now to tourists.

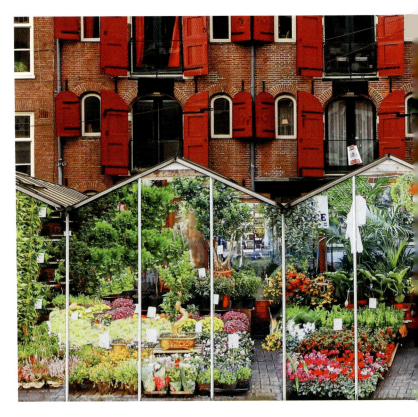

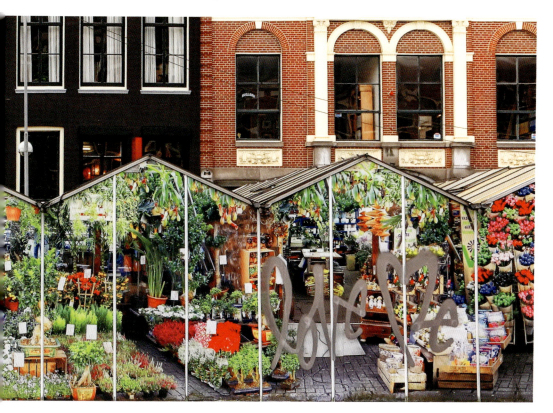

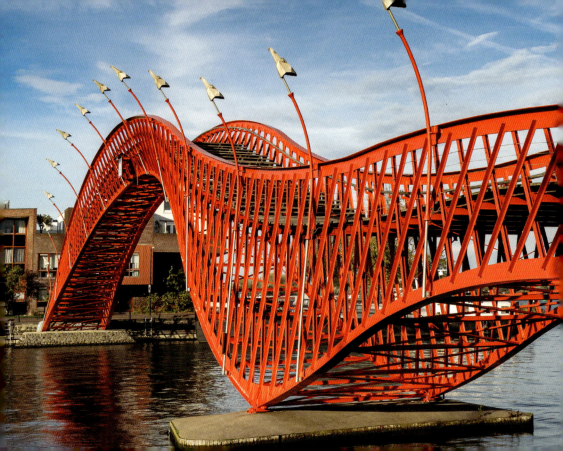

Pythonbrug, Oostelijk Havengebied
The pedestrian Python Bridge, officially the Hoge Brug, crosses the canal between Sporenburg and Borneo Island. The Oostelijk Havengebied (Eastern Docklands) area was deindustrialized from the 1980s.

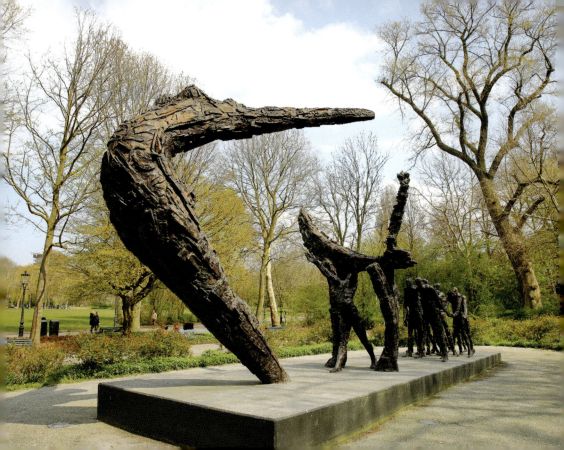

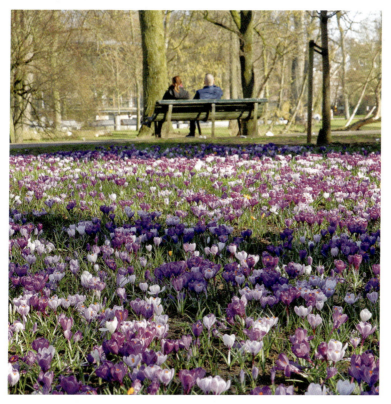

BOTH PHOTOGRAPHS:
Oosterpark
At the heart of the Oosterpark (Eastern Park) neighbourhood is this English garden, first laid out in the late 19th century by landscape designer Leonard Antonij Springer. The centrepiece is a 2002 National Slavery Monument (opposite).

RIGHT:
KNSM Eiland, Oostelijk Havengebied
Part of the chic Eastern Docklands redevelopment, this block was designed by Dutch architect Jo Coenen. The island's name stands for Koninklijke Nederlandsche Stoomboot-Maatschappij (Royal Dutch Steamboat Shipping), which once had its headquarters here.

OPPOSITE:
Zeeburgereiland, IJburg
The Netherlands' largest concrete skatepark takes centre stage on the island of Zeeburger. The park features tiled panels that offer a modern twist on traditional blue and white Delftware tiles.

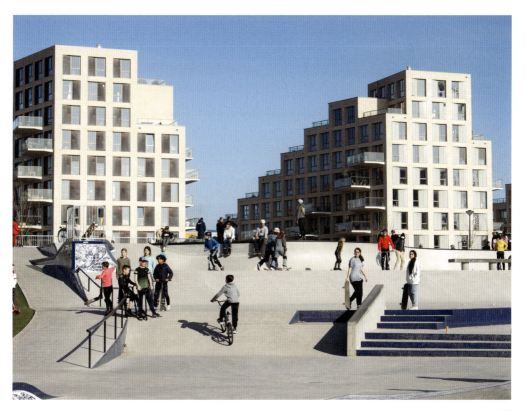

Herengracht, Grachtengordel

This wide, tree-lined canal was dug from 1612 for well-to-do merchants who desired to live away from the noise and stink of the harbour. Fittingly, the canal's name means 'Gentlemen's Canal'.

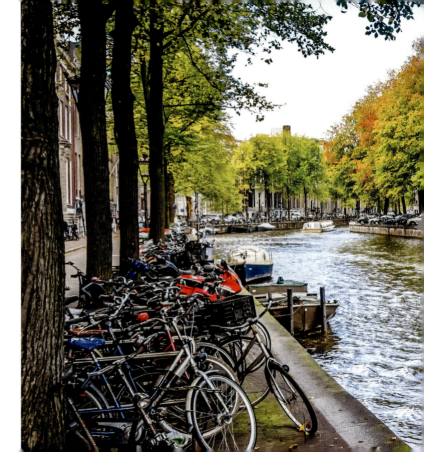

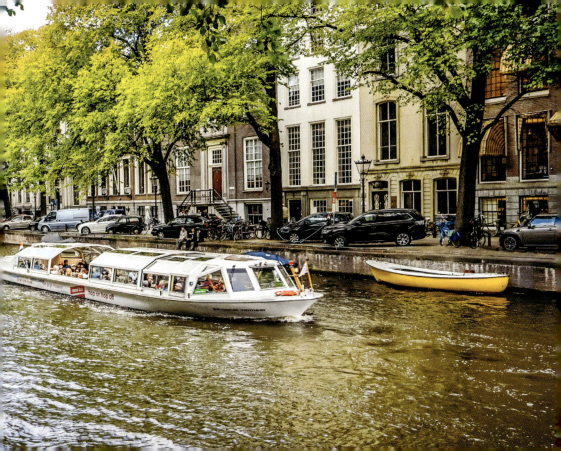

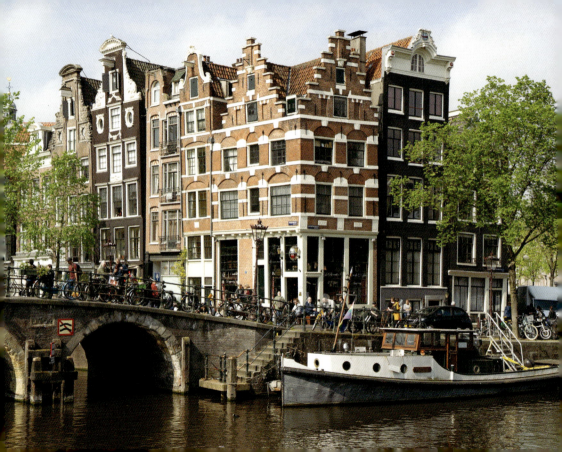

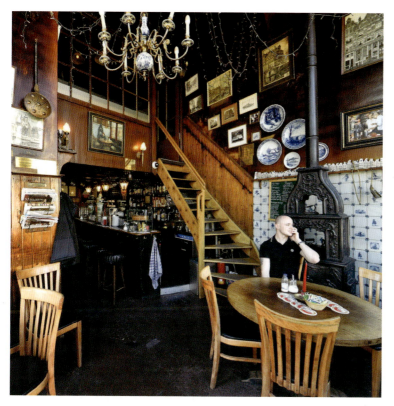

BOTH PHOTOGRAPHS:
Café Papeneiland, Jordaan

At the junction of Brouwersgracht and Prinsengracht is the 'Papist's Island' brown café. Opened in 1642, the café has a secret passage that once connected with a hidden Catholic church.

Singel, Grachtengordel
The Singel was a moat around Amsterdam until 1585, when the city expanded beyond it. Today, the canal is the innermost of the four main canals of the 'Canal Girdle' neighbourhood.

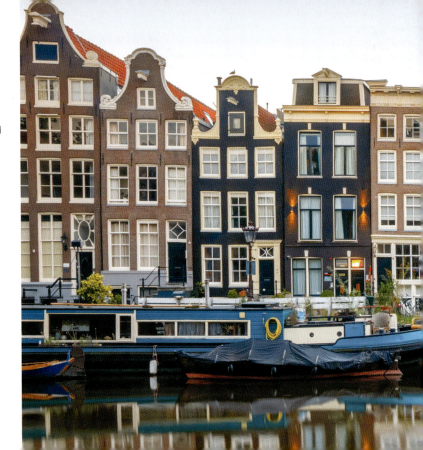

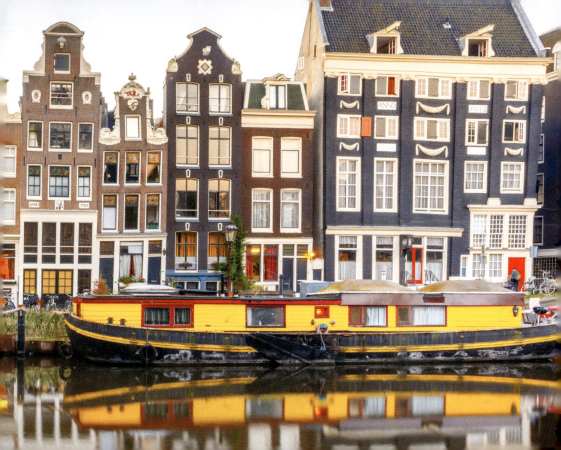

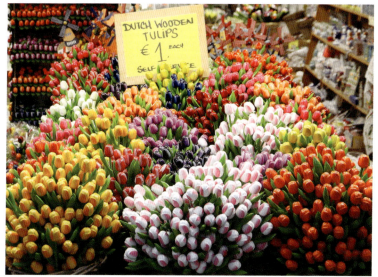

LEFT:
Singel, Grachtengordel
Among the goods to buy or admire on the elegant streets of the Grachtengordel are Dutch cheeses from Gouda to cumin-flavoured Leyden.

ABOVE:
Bloemenmarkt, Grachtengordel
Tulip mania is not new to the city: in the 17th century, demand for the blooms led to an economic bubble of soaring prices.

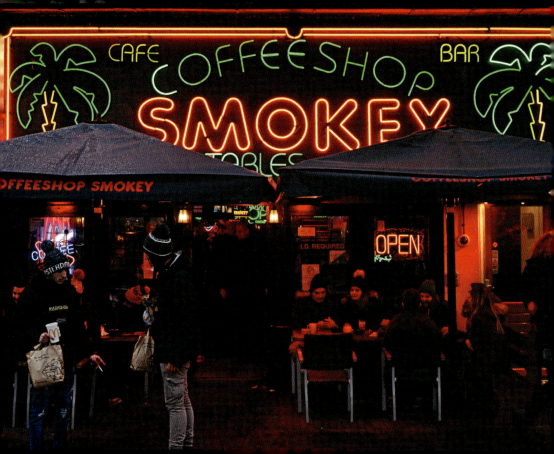

OPPOSITE:
Rembrandtplein, Grachtengordel
Once a butter market, Rembrandtplein has been a hub for nightlife since the early 20th century. It is known for its coffeeshops, bars and clubs.

LEFT:
Lindenmarkt, Jordaan
A market was first held on Lindengracht in 1894. Nowadays, the Saturday market hosts more than 230 stalls selling plants, cut flowers, vegetables and fish.

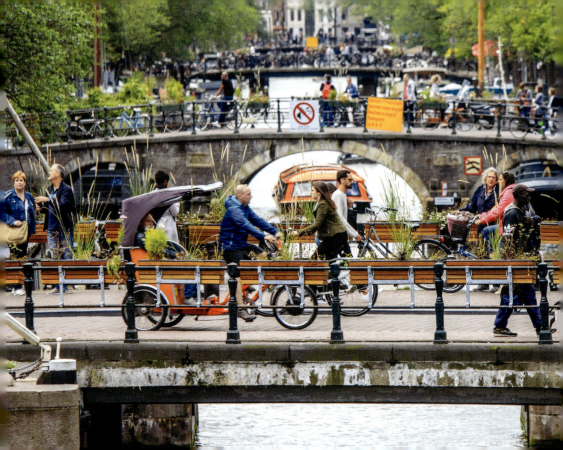

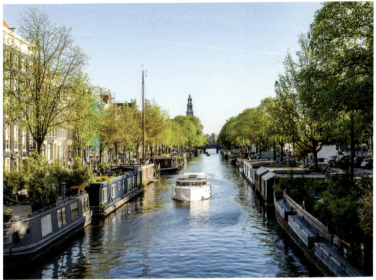

BOTH PHOTOGRAPHS:
Prinsengracht, Grachtengordel
The fourth and longest of the major canals that make up the Grachtengordel, Prinsengracht was constructed from 1612. Along the canal's 3.2-km (2-mile) journey from Brouwersgracht to the Amstel River, it is crossed by 14 bridges.

BOTH PHOTOGRAPHS:
Grachtengordel
Since 2010, Amsterdam's Grachtengordel has been a World Heritage Site, due to the engineering achievement of the neighbourhood's concentric canals and for its exquisite 17th-century gabled homes. Yet the neighbourhood is no museum piece, thanks in no small part to its many colourfully painted, enticing houseboats.

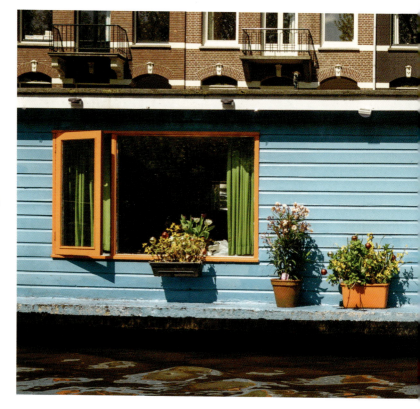

41

ABOVE:
Café Thijssen, Jordaan
Once a working district known for its tanneries and riots, today's Jordaan is the place to find cosy cafés, antique markets and artists' studios.

RIGHT:
Karthuizerhof, Jordaan
Hidden behind Jordaan's busier streets are several peaceful *hofjes* (almshouse courtyards). This one was built in 1650 for widows and unmarried mothers.

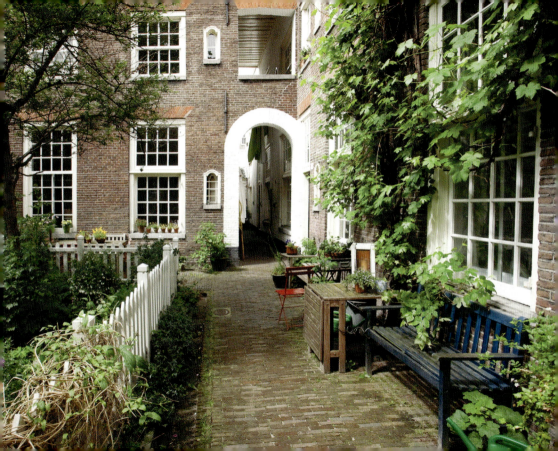

Noordermarkt, Jordaan

This quiet square on the western side of Prinsengracht springs into life on Monday mornings, when it hosts Amsterdam's cheapest clothes market. The square's solemn church, Noorderkerk, was designed by Hendrick de Keyser in the 1620s.

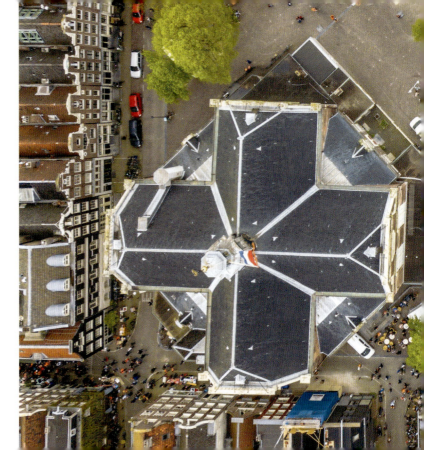

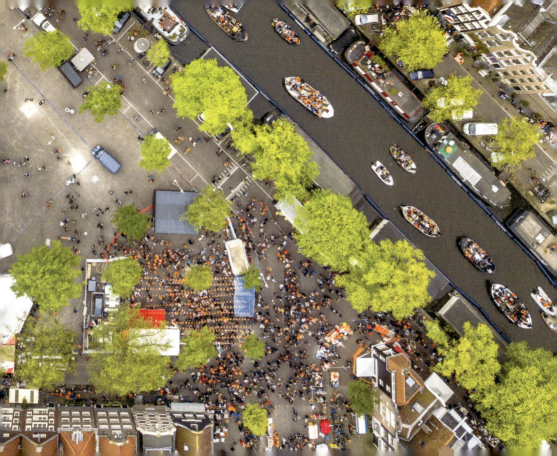

BOTH PHOTOGRAPHS:
Muntplein
At the meeting point of the Grachtengordel and Spui neighbourhoods, busy Muntplein is overlooked by the Munttoren clocktower (opposite), which was briefly used as a mint. Munttoren's steeple was designed by Hendrick de Keyser, who was also responsible for Noorderkerk, Zuiderkerk and Westerkerk.

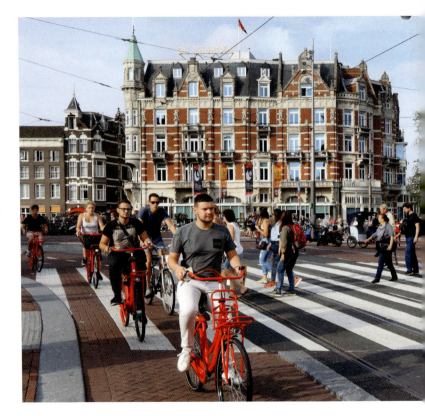

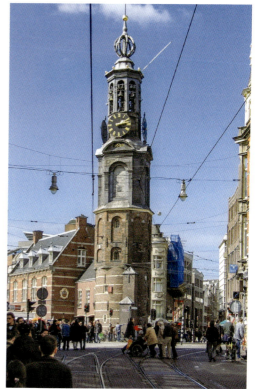

RIGHT TOP AND BOTTOM:
Artis Zoo, De Plantage
The Netherlands' oldest zoo lies in the leafy De Plantage neighbourhood, just east of the city centre. Founded in 1838, the zoo is home to more than 1,300 species.

FAR RIGHT:
Hortus Botanicus, De Plantage
This botanical garden was first planted in 1638 as a herb garden for the city's doctors and apothecaries. The 1912 Palm House was designed by Amsterdam School architect Johan Melchior van der Mey.

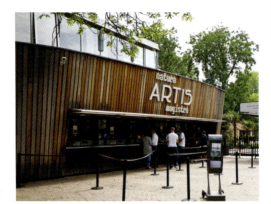

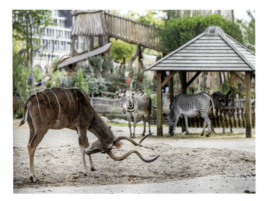

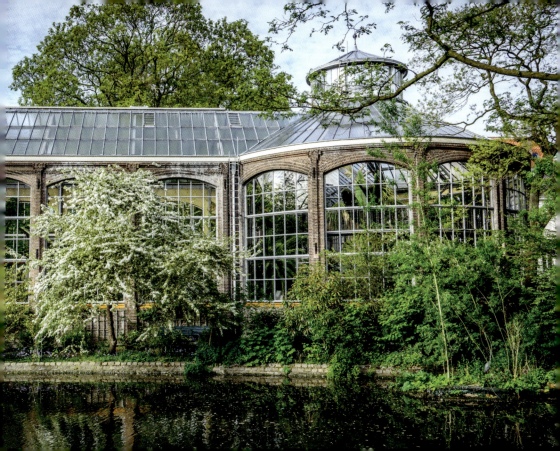

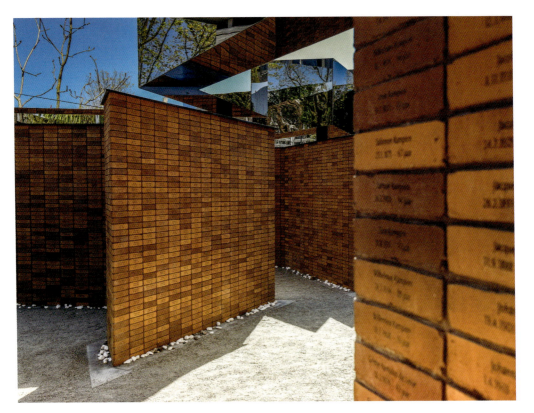

OPPOSITE:

Holocaust Namenmonument, De Plantage

On the outskirts of the old Jewish Quarter is the Holocaust Names Memorial, which lists the names of 102,000 Jewish, Roma and Sinti victims of the Holocaust from the Netherlands.

LEFT:

Wertheimpark, De Plantage

This central but peaceful park is named after Jewish philanthropist Abraham Carel Wertheim. It holds the city's Auschwitz Monument, its broken mirrors created by artist Jan Wolkers.

ALL PHOTOGRAPHS:
Waterlooplein Flea Market, Jodenbuurt
At the heart of the Jewish Quarter is Waterlooplein, which hosts a flea market from Monday to Saturday. More than 300 stalls sell secondhand clothing and bric-a-brac.

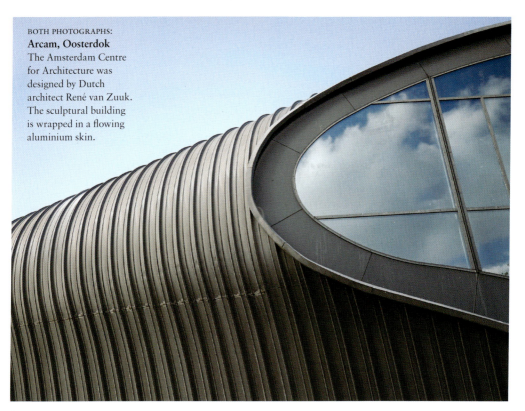

BOTH PHOTOGRAPHS:
Arcam, Oosterdok
The Amsterdam Centre for Architecture was designed by Dutch architect René van Zuuk. The sculptural building is wrapped in a flowing aluminium skin.

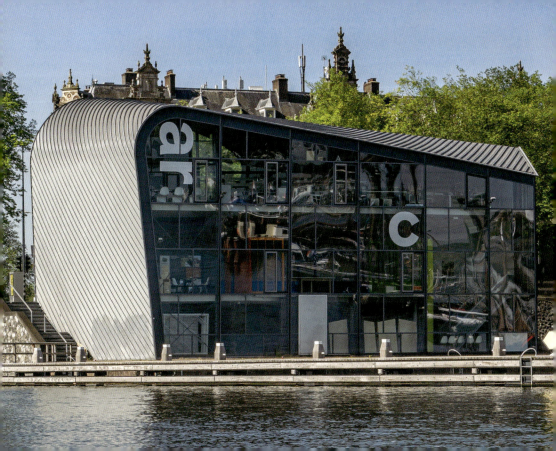

ABOVE:
Rembrandtplein, Grachtengordel
This square is named after one-time local resident Rembrandt van Rijn. He is honoured by Amsterdam's oldest public statue (centre), made from iron in 1852.

OPPOSITE:
De Negen Straatjes, Grachtengordel
'The Nine Streets' are stylish sidestreets that connect the four canals of the western Grachtengordel. The streets are lined with boutiques, galleries and upmarket cafés.

BOTH PHOTOGRAPHS:
Dam Square, Centrum
On the site of the original 13th-century dam on the River Amstel, Dam Square bustles with performers, tourists and pigeons. At its centre is the National Monument, a white stone cenotaph that honours the dead of World War II.

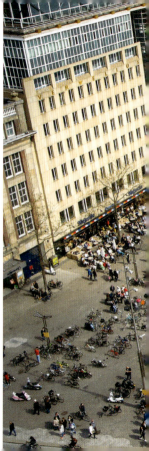

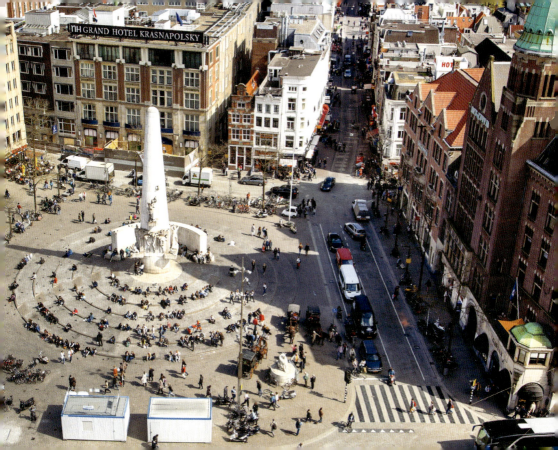

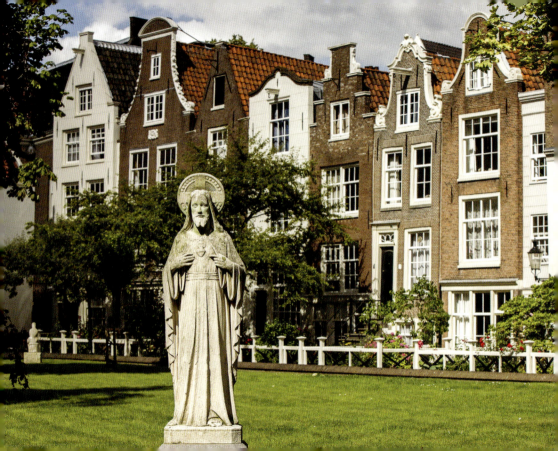

FAR LEFT:

Begijnhof, Centrum

One of the city's oldest *hofjes* (almshouse courtyards), the Begijnhof was probably founded in the 14th century. The last *beguine* (a member of the community's lay religious order) died in 1971.

LEFT:

Vettewinkel Fabriek, Centrum

The old Vettewinkel paint and varnish factory, on the Oudezijds Kolk canal, was built in 1889. The building was gutted by fire in 1973, but the striking, shuttered facade remains.

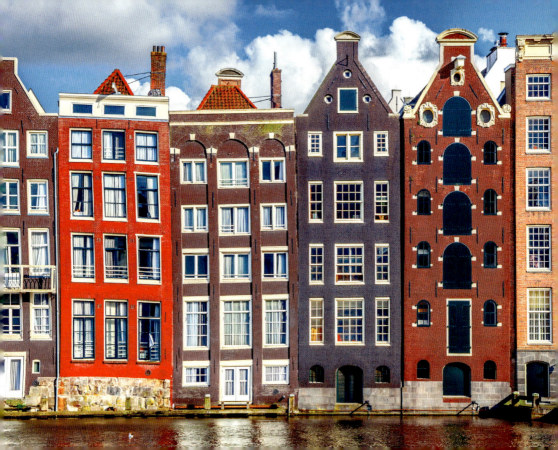

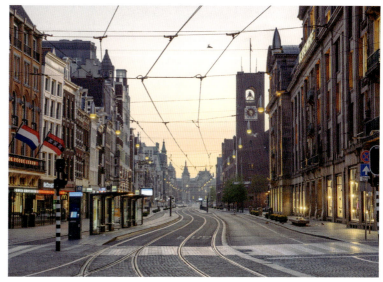

LEFT:
Damrak, Centrum
Called 'The Dancing Houses' for their crookedness, these homes were – like other buildings in Amsterdam – built narrow to save on tax.

ABOVE:
Damrak, Centrum
This avenue runs from Centraal Station to Dam Square. The street takes its name from a '*rak*' (straight section) of the Amstel near the old dam.

BOTH PHOTOGRAPHS:
PC Hooftstraat, Oud-Zuid
Probably the most upscale shopping street in the
Netherlands, PC Hooftstraat lies in the desirable
residential district of 'Old South'. Nearby shopping
streets include chic Van Baerlestraat and Beethovenstraat.

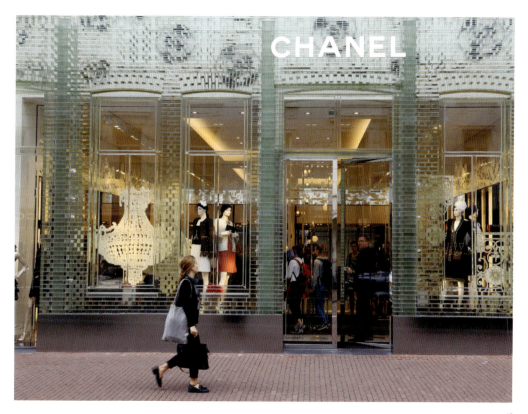

Zuidas

The business district lies in the south of this otherwise low-rise city, between the Rivers Amstel and Schinkel. Notable building complexes include the three jagged, stone-and-glass towers of Valley (right).

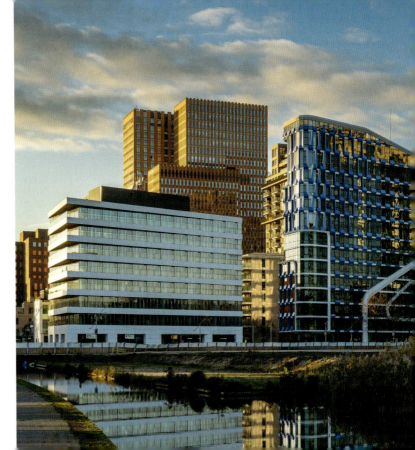

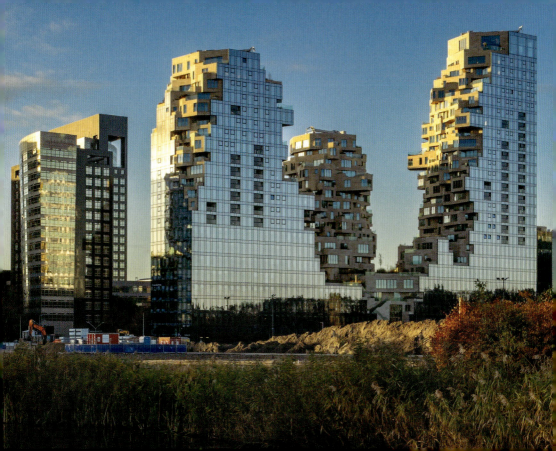

BOTH PHOTOGRAPHS AND OVERLEAF:
Vondelpark, Oud-Zuid
Named after the 17th-century playwright Joost van den Vondel, this large park opened in 1865. Amid the lakes and meandering pathways of the English-style garden is a wrought-iron bandstand (overleaf) constructed in 1873.

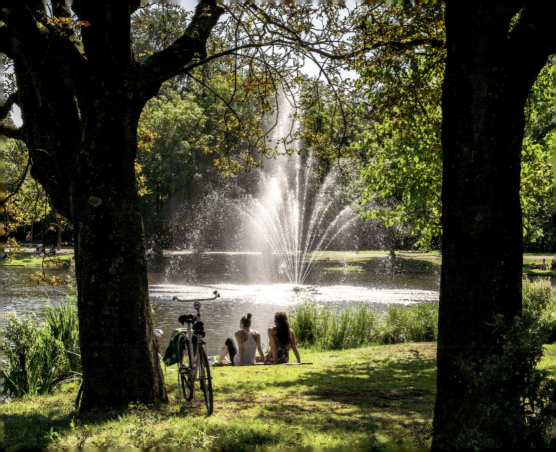

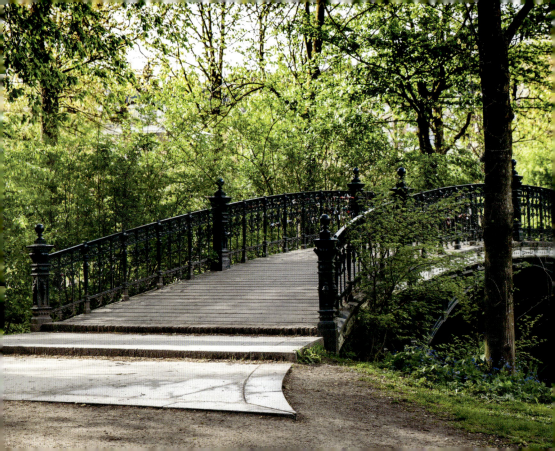

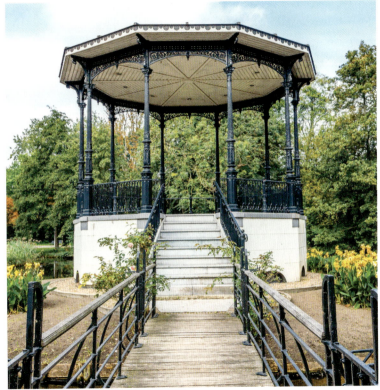

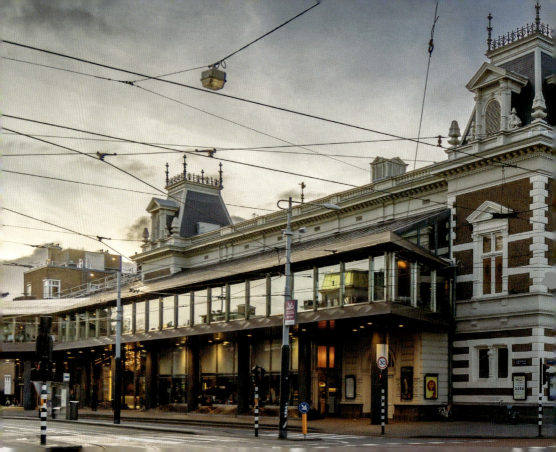

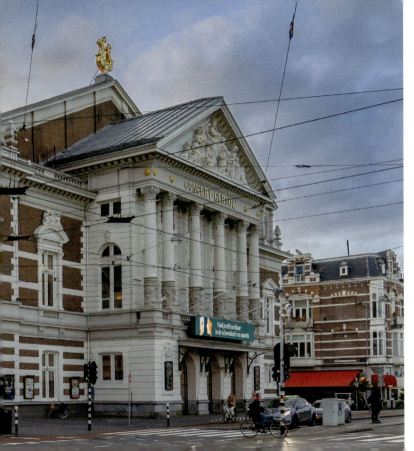

Concertgebouw, Oud-Zuid

The prosperous Oud-Zuid neighbourhood is the site of many major cultural attractions, including the Concertgebouw, Rijksmuseum, Van Gogh Museum and Stedelijk Museum. The Concertgebouw, known for its excellent acoustics, opened in 1888.

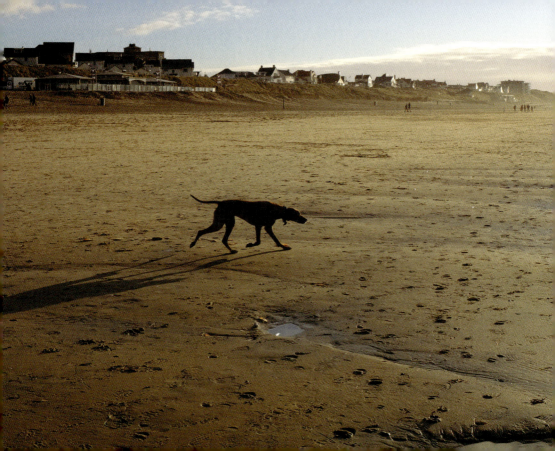

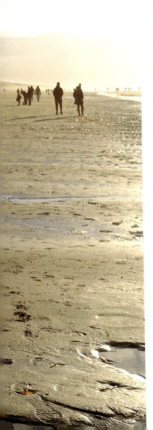
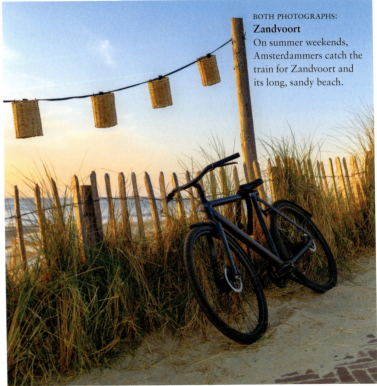

BOTH PHOTOGRAPHS:
Zandvoort
On summer weekends, Amsterdammers catch the train for Zandvoort and its long, sandy beach.

RIGHT:
Zaandam
On the River Zaan about 12 minutes by train from Amsterdam, central Zaandam has undergone major redevelopment. The new Inntel Hotel (left) resembles a stack of wooden houses.

OPPOSITE:
Zaanse Schans
Just outside Zaandam are the working windmills of Zaanse Schans, which were mostly relocated here in the 1960s and 1970s. The mills include sawmills, oilmills, a mustardmill and a dyemill.

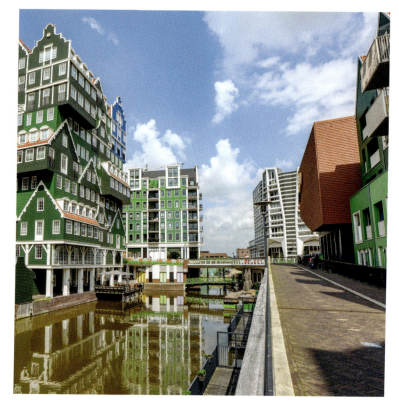

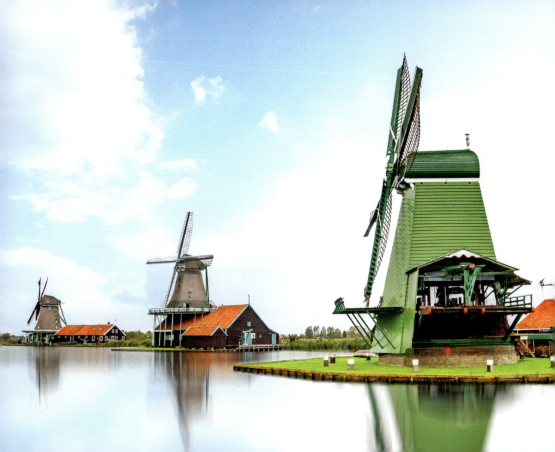

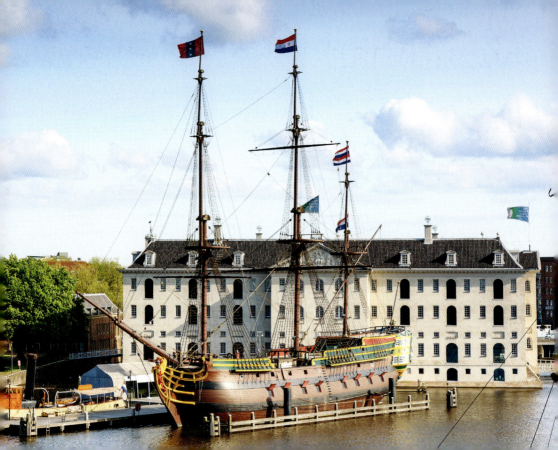

Landmarks & Museums

In a city as low-rise as Amsterdam, many of the landmarks are those that can be glimpsed above the surrounding canal houses or those squatter creations that grace its waterfront or wide squares. Among the former are the many steeples designed by the prolific 17th-century architect Hendrick de Keyser, including the Zuiderkerk, Westerkerk and Montelbaanstoren. In the 19th century, the workaholic Pierre Cuypers created some of those squatter monuments, including the Rijksmuseum and Centraal Station. In the early 20th century, it was the turn of architects of the Amsterdam School, fathered by HP Berlage, to make their mark on the city with their organic brickwork. It is too soon to say which of Amsterdam's contemporary architects will, in future centuries, be viewed as equally influential. One name for discussion might be Jo Coenen, whose striking work has helped to rejuvenate the docklands. Many of Amsterdam's most renowned museums, from the Rijksmuseum to the waterfront's groundbreaking Eye Filmmuseum and NEMO Science Museum, are housed in its landmarks. Lesser-known and quirkier museums, such as the delightful KattenKabinet and Electric Ladyland, are housed in less eye-catching canal houses, warehouses and houseboats. The unmissable Anne Frank Huis is in a building whose very ordinariness tried to shield its secret inhabitants from extraordinary cruelty.

OPPOSITE:

Scheepvaartmuseum, Oosterdok
The National Maritime Museum is housed in a 17th-century naval storehouse. Moored outside is a replica of the *Amsterdam*, which sank on a voyage between the Netherlands and Indonesia in 1749.

BOTH PHOTOGRAPHS:
Scheepvaartmuseum, Oosterdok
Setting the scene for its exhibits, the National Maritime Museum's courtyard roof was inspired by the rhumb lines on nautical charts of the Golden Age. A star exhibit is the Royal Barge of King William I, completed in 1818.

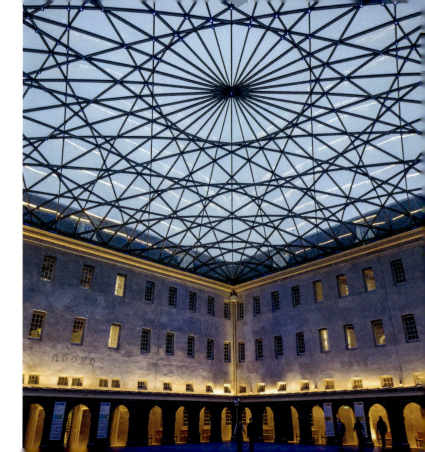

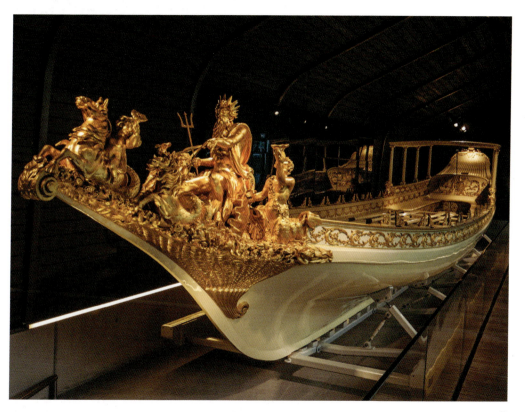

RIGHT:

Anne Frank Huis, Grachtengordel

This important museum preserves the wartime hiding place of the Jewish diarist Anne Frank, who died in Bergen-Belsen concentration camp in 1945, aged 15. Published in 1947, her diary has sold 30 million copies.

OPPOSITE:

Amsterdam Cheese Museum, Jordaan

Offering a wide variety of cheeses to taste and buy, this museum-cum-store also gives tourists the chance to dress up as a Dutch dairy farmer.

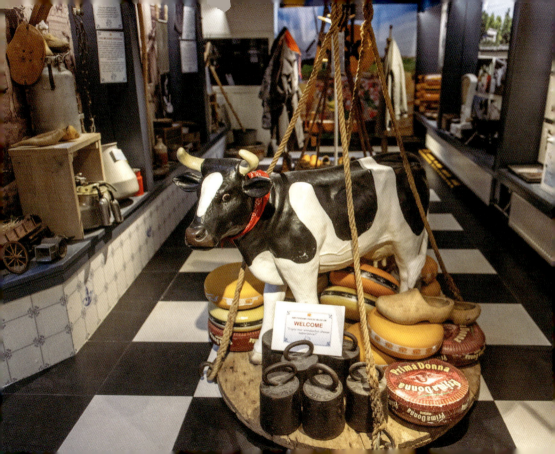

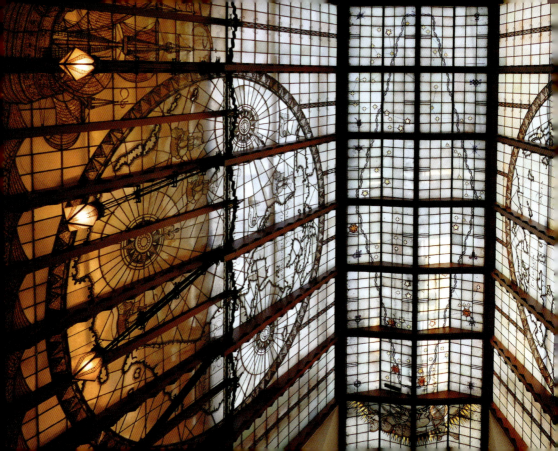

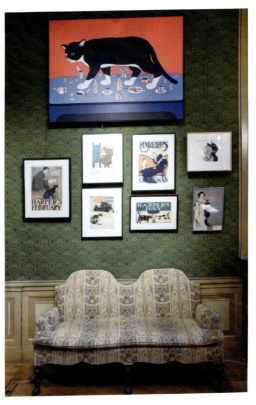

FAR LEFT:

Scheepvaarthuis, Oosterdok

Now a hotel, these shipping offices were built from 1913 in the style of the Amsterdam School. The intricate glass ceiling above the main stairwell is decorated with both constellations and maps.

LEFT:

KattenKabinet, Grachtengordel

Located in a canal house, this museum is dedicated to cat-related works of art. Its prize pieces are by Rembrandt, Picasso and Toulouse-Lautrec.

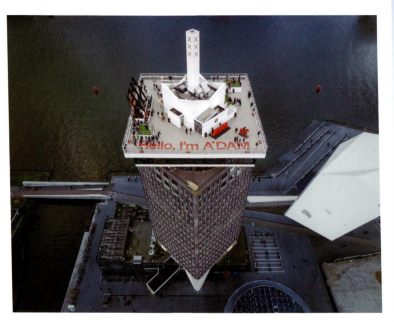

BOTH PHOTOGRAPHS:
A'DAM Toren, Overhoeks
Across the IJ from Centraal Station is the redeveloped Overhoeks neighbourhood, with its landmark A'DAM (Amsterdam Dance And Music) tower. On the tower's observation deck is Europe's highest swing.

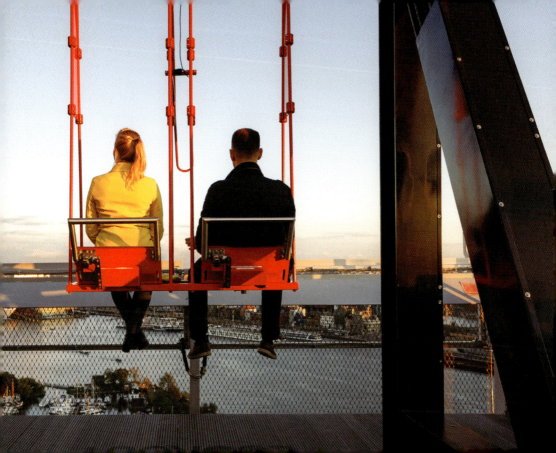

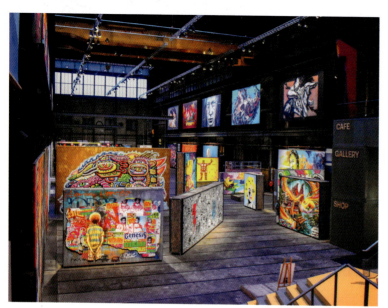
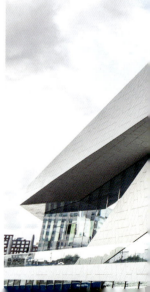

ABOVE:
STRAAT, NDSM-Werf
Reached by a free ferry from Centraal Station, this museum of street art is housed in a warehouse on hip NDSM wharf.

RIGHT:
Eye Filmmuseum, Overhoeks
This soaring, IJ-reflecting building was opened in 2012 to house a cinema, archive and museum.

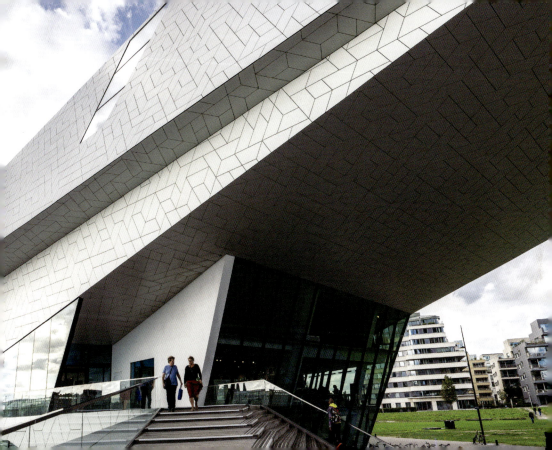

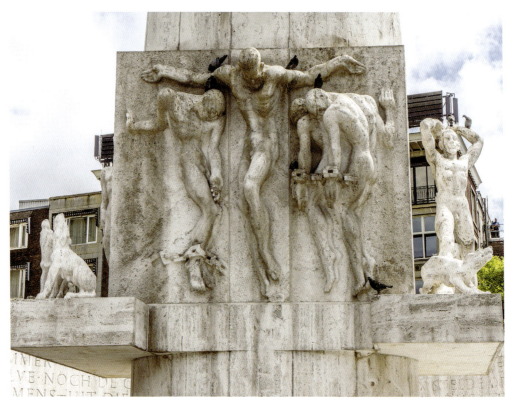

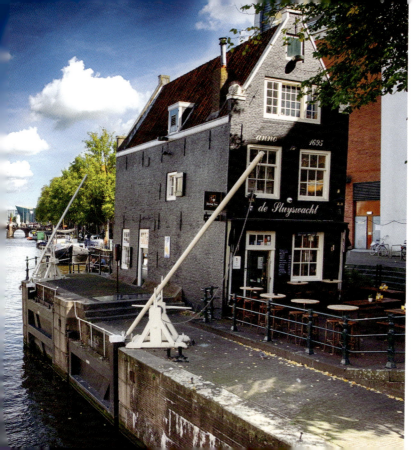

OPPOSITE:

National Monument, Dam Square, Centrum
Completed in 1956, this cenotaph bears expressive reliefs by Dutch sculptor Paul Grégoire. The De Vrede ('Peace') relief shows four chained men who represent the suffering endured in World War II.

LEFT:

Café de Sluyswacht, Jodenbuurt
Housed in a lopsided lockhouse dating from 1695, this traditional café is popular with elderly locals and students. It is a good place to sample local beers and *bitterballen*.

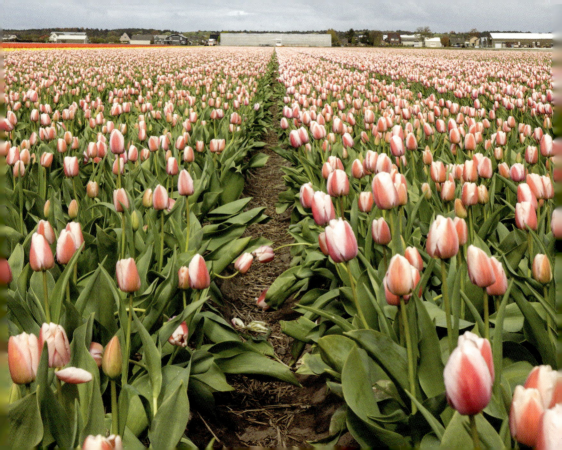

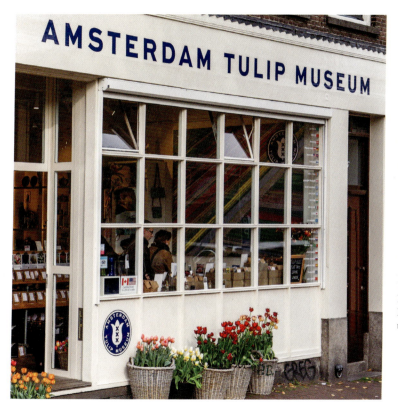

OPPOSITE:
Bollenstreek
The 'Bulb Region' stretches between Haarlem and Leiden. In spring, when the tulips, crocuses, daffodils, hyacinths and asters are blooming, the area makes a popular day trip from Amsterdam.

LEFT:
Amsterdam Tulip Museum, Jordaan
This museum showcases the history of the tulip. Although no one knows for sure, the flower may have been brought to northwestern Europe by Oghier Ghislain de Busbecq, a 16th-century Flemish ambassador to the Ottoman Empire.

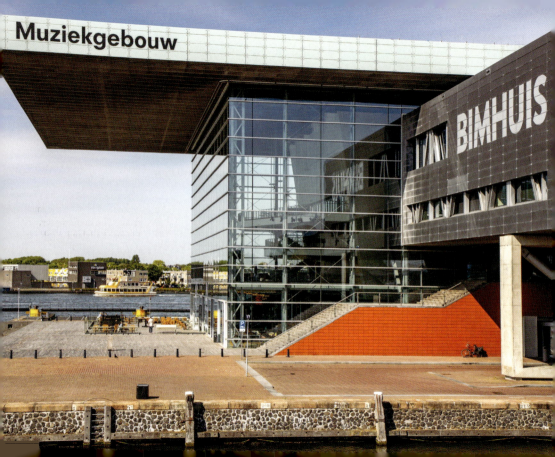

OPPOSITE:

Muziekgebouw aan 't IJ, Waterfront

Jutting over the IJ, this bold and blocky 2005 concerthall hosts performances of contemporary classical and jazz music.

LEFT:

Electric Ladyland, Jordaan

The world's first museum focused on fluorescence, Electric Ladyland displays minerals, art and products that glow under ultraviolet light.

BOTH PHOTOGRAPHS:
Nieuwe Kerk, Dam Square, Centrum
When Amsterdam outgrew the Oude Kerk in De Wallen, permission was given for a new church in 1380. That church, since revamped in Gothic and neo-Gothic styles, now hosts regular organ recitals. One of its windows showcases Amsterdam's coat of arms, which features three St Andrew's crosses.

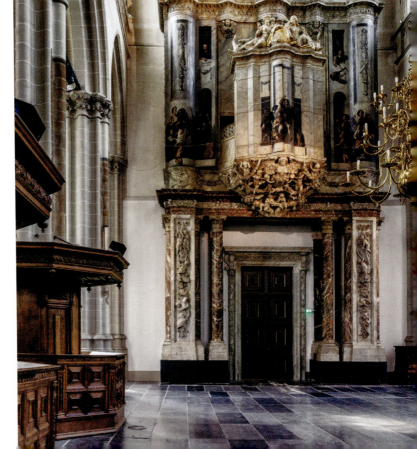

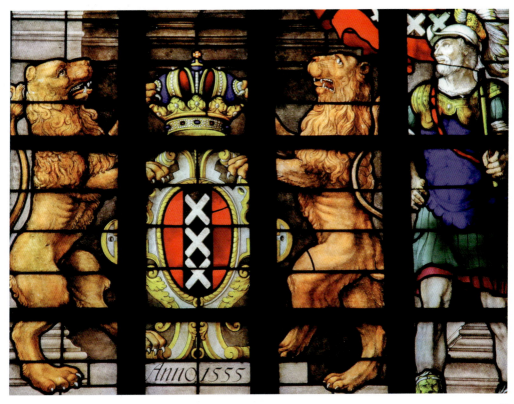

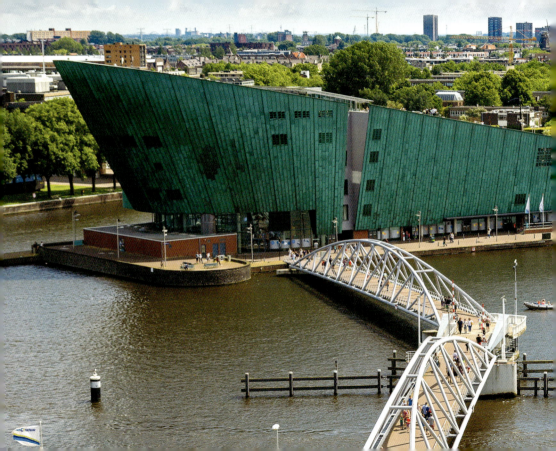

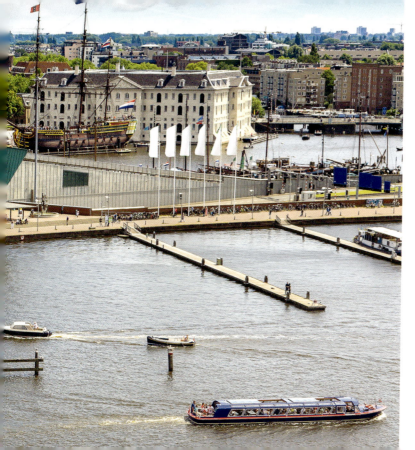

NEMO Science Museum, Oosterdok

The country's largest science museum is housed in a 1997 building by Italian architect Renzo Piano. Supported on piles, the boat-like, copper-clad structure is built on top of the tunnel under the IJ.

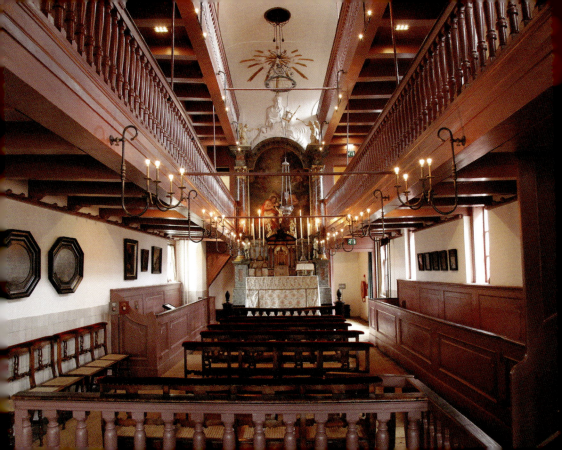

OPPOSITE:
Ons' Lieve Heer op Solder, De Wallen
The 'Our Lady in the Attic' museum gives an opportunity to view the interior of a 17th-century canal house, as well as a *schuilkerk* (hidden church) where religious dissenters worshipped secretly.

LEFT:
NEMO Science Museum, Oosterdok
NEMO offers films, experiments and hands-on exhibits, on topics from DNA to the water cycle. Every year, it is visited by around 700,000 people.

BOTH PHOTOGRAPHS:
Posthoornkerk, Grachtengordel
This three-spired church was designed in 1860 by Dutch neo-Gothic architect Pierre Cuypers, who was responsible for other monumental landmarks such as Centraal Station and the Rijksmuseum.

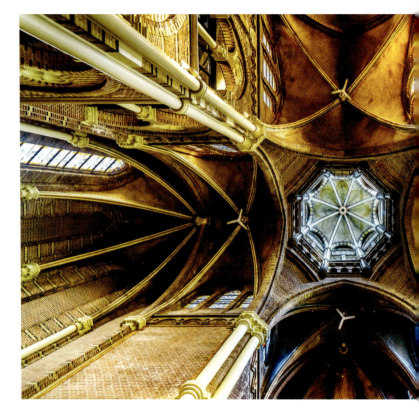

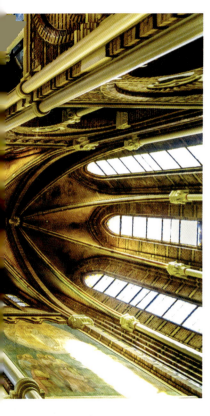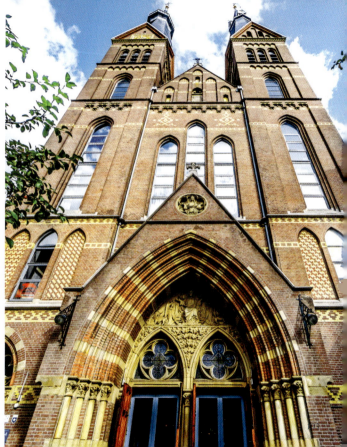

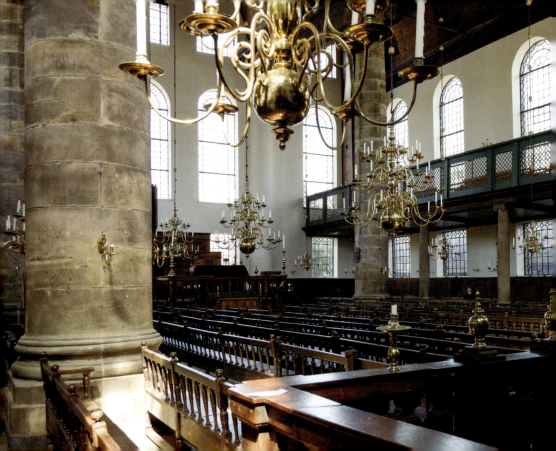

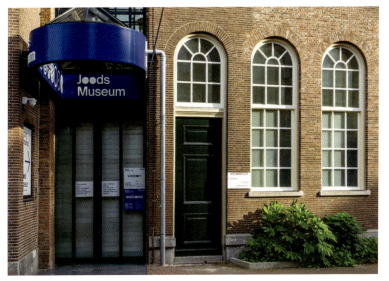

LEFT:
Esnoga, Jodenbuurt
The floor of this 1675 Sephardic synagogue was once covered in sand to soak up moisture. With no electric supply, the brass chandeliers hold candles.

ABOVE:
Joods Museum, Jodenbuurt
Across the road from the Esnoga, this museum focuses on Jewish traditions, culture, art and ceremonial objects.

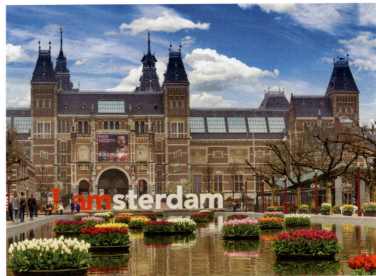

LEFT:
Stedelijk Museum, Oud-Zuid
This museum of modern art is housed in a 19th-century building with a 21st-century addition nicknamed the 'bathtub'.

ABOVE:
Rijksmuseum, Oud-Zuid
A vast museum of art and history, the national museum is based in a neo-Gothic building designed by Pierre Cuypers and completed in 1885.

BOTH PHOTOGRAPHS:
Willet-Holthuysen, Grachtengordel
Located on the Herengracht, this 17th-century canal house preserves stately salons and boudoirs. There are fine works by artist and decorator Jacob de Wit, as well as still lifes by Adriana Johanna Haanen.

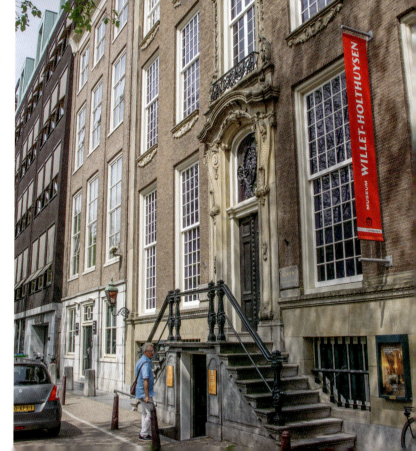

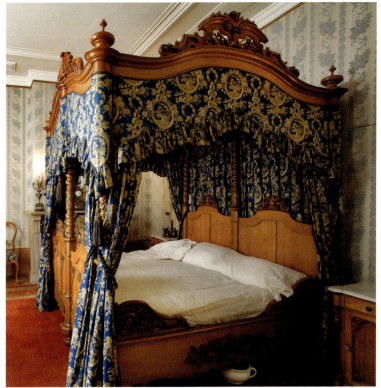

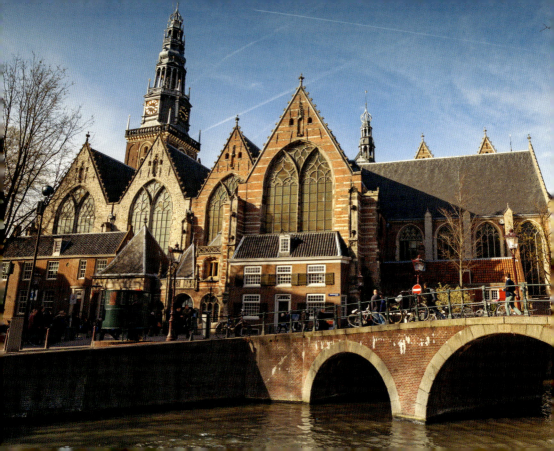

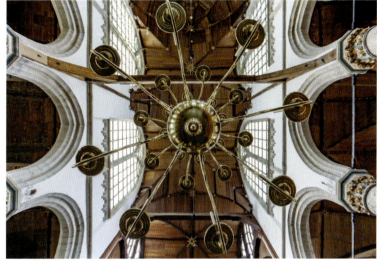

BOTH PHOTOGRAPHS:
Oude Kerk, De Wallen
Consecrated in 1306, the Old Church is Amsterdam's oldest building, although much of what can be seen today was part of a 16th-century Renaissance expansion and remodelling. The vaulted ceiling, made of Estonian oak planks, has been dated to 1390.

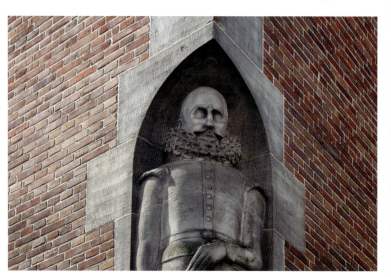

ABOVE:
Beurs van Berlage, De Wallen
This former commodity exchange was completed in 1903 by Hendrik Petrus Berlage, one of the fathers of the Amsterdam School.

RIGHT:
Wereldmuseum, Oosterpark
Completed in 1926, this building houses an ethnographic museum with exhibits from Asia, Africa and the Americas.

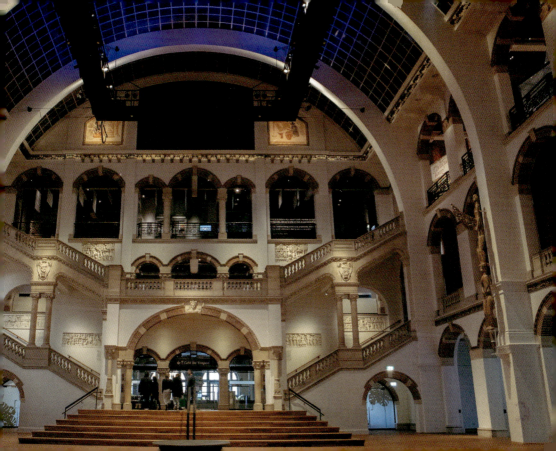

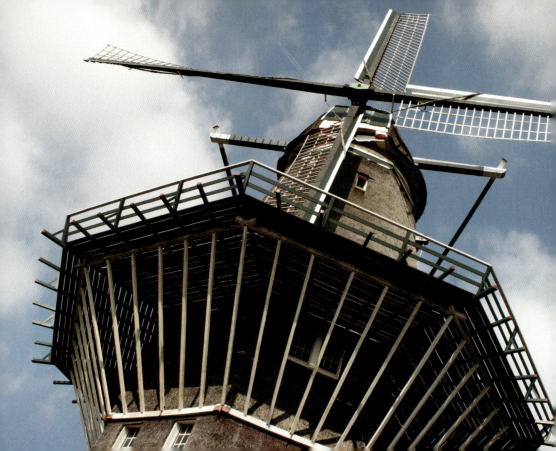

LEFT:
De Gooyer, Kadijken
At more than 26 m (85 ft) high, this is the tallest wooden mill in the Netherlands. The octagonal mill, built in 1814, stands on a stone foundation. Although the mill's sails still turn, they are not connected to a grinding mechanism.

RIGHT:
Zuiderkerk, Centrum
Designed by Hendrick de Keyser, the 1614 belltower of Zuiderkerk dominates the skyline of the Nieuwmarkt area. Its elegant silhouette and Ionic columns are said to have inspired Sir Christopher Wren's London churches.

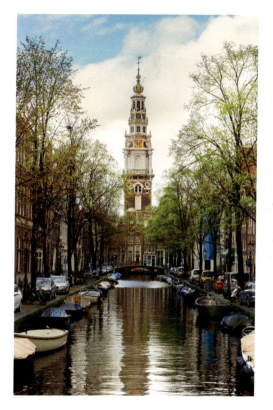

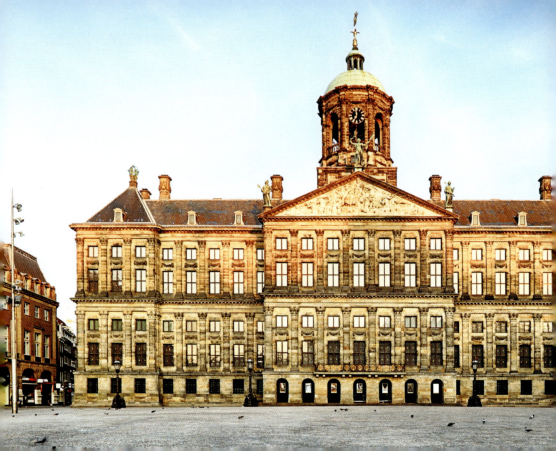

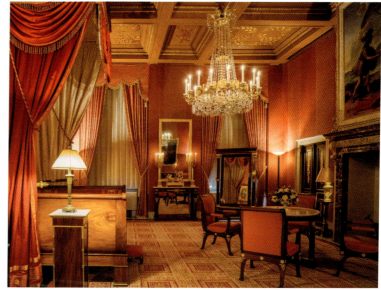

BOTH PHOTOGRAPHS:
Koninklijk Paleis, Centrum
Built as Amsterdam's town hall, the Royal Palace was completed in 1665. It was converted into a palace by Louis Bonaparte, who became Louis I of Holland in 1806. His bedroom (above) showcases opulent Empire-style furniture.

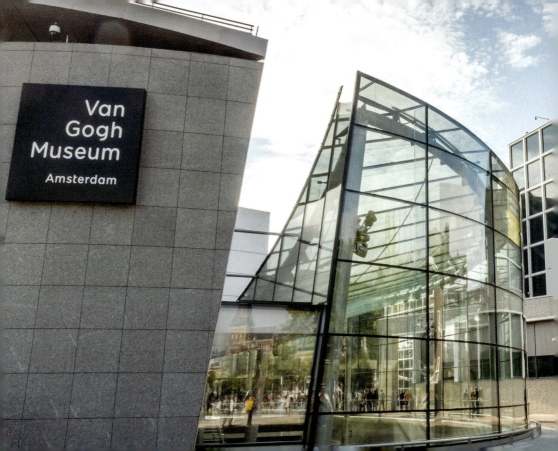

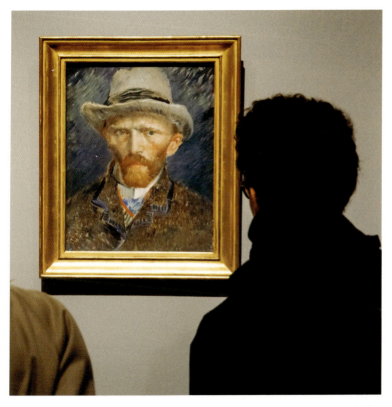

OPPOSITE:
Van Gogh Museum, Oud-Zuid
Dedicated to the Post-Impressionist Dutch painter Vincent van Gogh (1853–90), this museum holds 200 paintings, 400 drawings and 700 letters by the artist.

LEFT:
Rijksmuseum, Oud-Zuid
This 1887 self-portrait by Van Gogh was painted soon after he moved to Paris to see the new, colourful style of painting, later called Post-Impressionism, that was being spearheaded by the likes of Paul Gauguin.

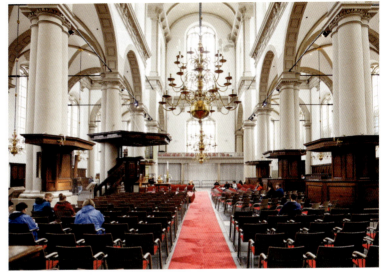

LEFT:
Houseboat Museum, Grachtengordel
In the *Hendrika Maria*, a barge built in 1914, this museum gives an enticing insight into life on a houseboat.

ABOVE:
Westerkerk, Grachtengordel
Built between 1620 and 1631 by Hendrick de Keyser, this Renaissance church was the resting place of Rembrandt.

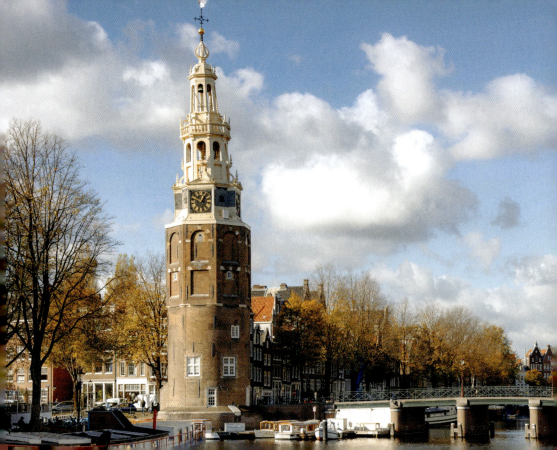

LEFT:

Montelbaanstoren, Centrum

Built in 1516 as part of Amsterdam's defensive wall, this tower was given a graceful Renaissance spire by Hendrick de Keyser in 1606.

RIGHT:

Amsterdam Museum, Centrum

Located in a former orphanage, this museum focuses on Amsterdam's history from the Middle Ages onward. Like many structures in Amsterdam, the Kalverstraat building is lopsided due to the swampy ground.

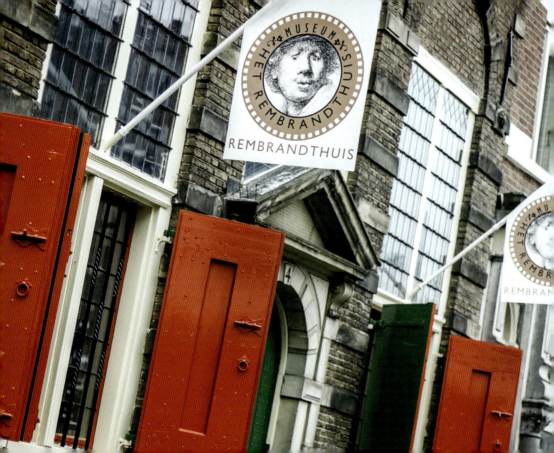

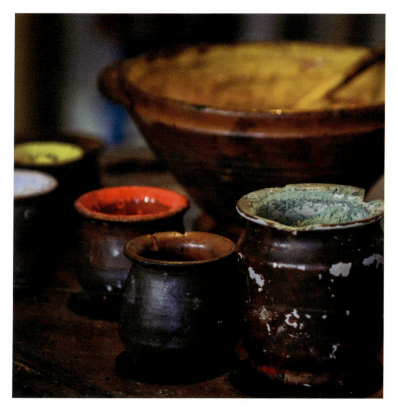

BOTH PHOTOGRAPHS
AND OVERLEAF:
**Rembrandthuis,
Jodenbuurt**
Rembrandt van Rijn
(1606–69) lived in this
house on Jodenbreestraat
from 1639 to 1658. The
artist's living and working
quarters have been
restored, while the modern
annexe displays many of
his etchings.

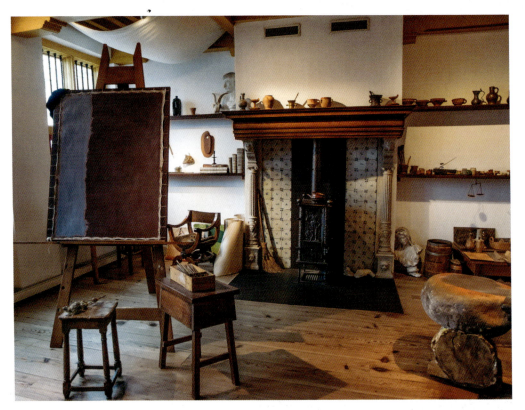

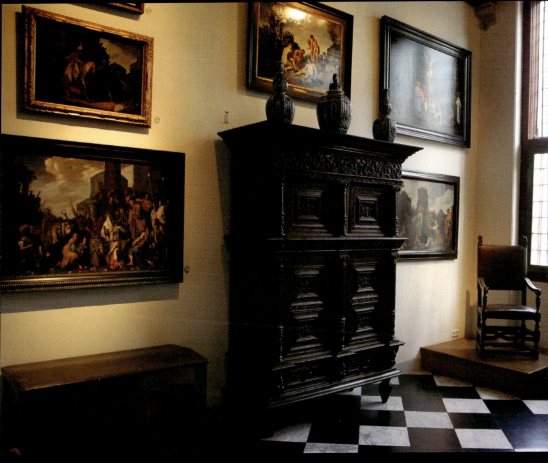

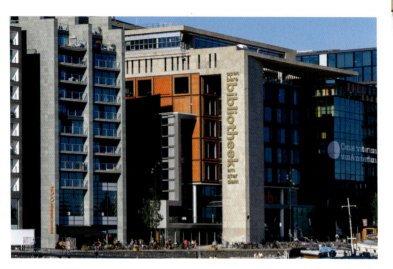

BOTH PHOTOGRAPHS:
OBA Oosterdok
Amsterdam's Central Library moved to a monumental new building on Oosterdok in 2007. Designed by Dutch architect Jo Coenen, who also masterminded the nearby KNSM Island, this is the largest library in the Netherlands, with an area of 28,000 sq m (300,000 sq ft).

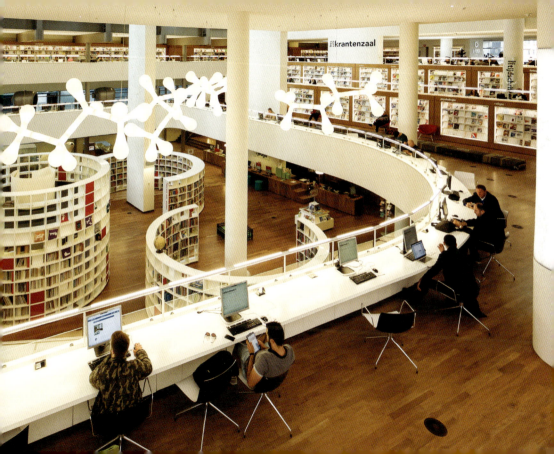

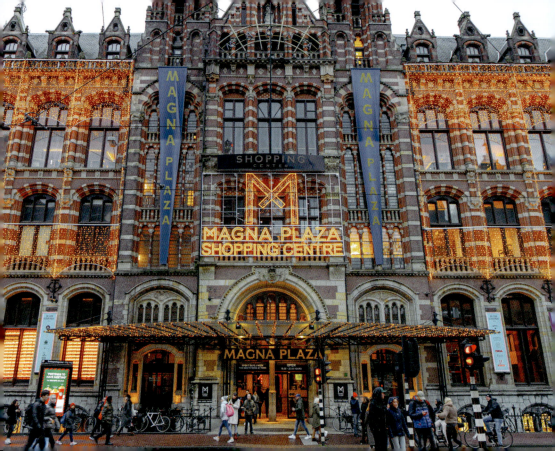

Shopping & Restaurants

This city of merchants has been renowned for its shopping since the Golden Age. Today, the city's goods – from Dutch tulips and Delftware to Americana and African textiles – can be browsed and bought in a vast array of markets, speciality shops and department stores. High-end clothes and accessories are found on the exclusive streets of Oud-Zoud around PC Hooftstraat, while chain stores line the crowded streets of the old town around Kalverstraat. In the Grachtengordel, the charming Spiegelkwartier offers art and antiques, while the Negen Straatjes are strewn with boutiques and vintage stores. Of all the city's myriad markets, lively Albert Cuypmarkt is the largest and certainly the busiest.

Just like its goods, the city's food ranges from local to international. Simple *eetcafés*, snackbars and pancake houses offer Dutch specialities from *stamppot* to *stroopwafels*, as well as steaming cones of *frites*. Fancier fare is found in famed hotel restaurants and Michelin-starred inns. Thanks to the city's long history of travel and immigration, fusion cuisine was on the menu in these eateries long before it hit New York. In addition, every neighbourhood has countless restaurants that serve specialist international cuisine, from Indian to Italian and Indonesian. Many of the city's tastiest specialities hail from the last of these, including *rijsttafel* (rice table), a meal of rice and spicy side dishes with its roots in Padang.

OPPOSITE:
Magna Plaza, Centrum
Amsterdam's former post office was converted into a shopping centre in 1992, leaving its facade – elaborately decorated with polychromatic brickwork – intact. The vast neo-Gothic building was completed in 1899.

BOTH PHOTOGRAPHS:
Magna Plaza, Centrum
The old post office building is nicknamed 'Perenburg' (pearburg) due to the pear-shaped domes on its towers. Inside is a magnificent neo-Renaissance galleried hall.

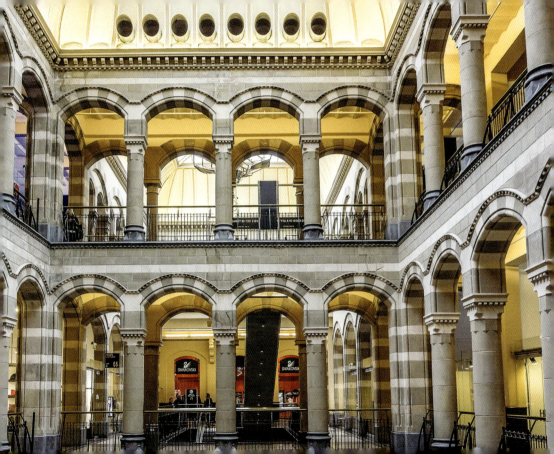

Kalverstraat, Centrum
Running from Dam Square to Muntplein, this famous, perennially crowded shopping street is lined with chain stores, souvenir shops and restaurants. The street is named for the calf market that was once held here.

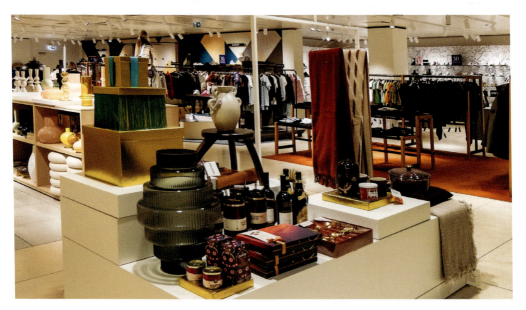

ABOVE:
De Bijenkorf, Dam Square, Centrum
Founded in 1870, the Bijenkorf ('Beehive') chain of department stores has its flagship outlet on Dam Square. It stocks a wide range of good-quality merchandise, from designer shoes to lingerie.

OPPOSITE:
Leidsestraat, Grachtengordel
Running from Koningsplein to Leidseplein, this street is known for its many shoe shops, particularly at its northern end. In the Dutch version of Monopoly, Leidsestraat is the second most expensive street.

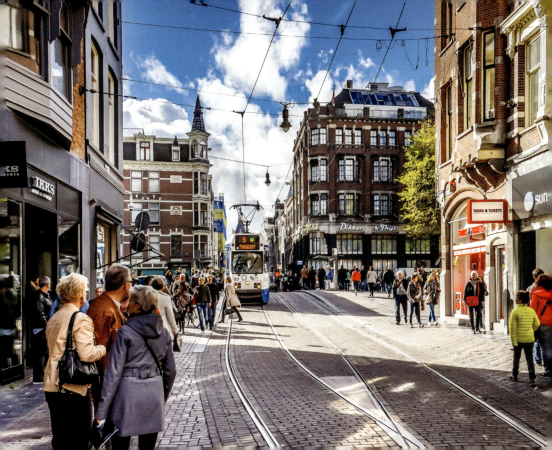

BOTH PHOTOGRAPHS:
Restaurant de Kas, Oost
Located in a greenhouse in Frankendael Park in the leafy reaches of eastern Amsterdam, de Kas serves vegetables and herbs that are grown on site. It is one of more than 20 Michelin-rated restaurants in Amsterdam.

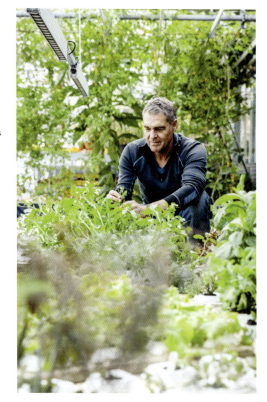

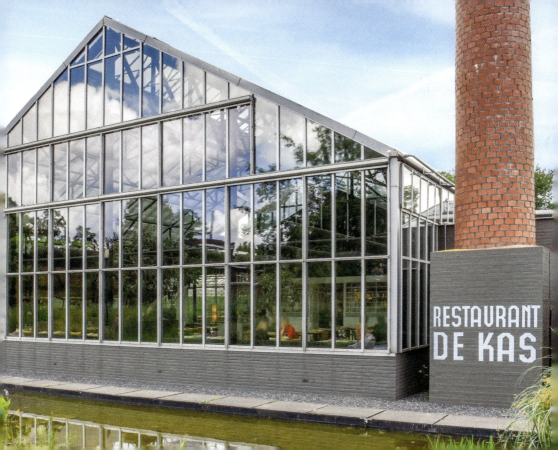

BOTH PHOTOGRAPHS:
Albert Cuypmarkt, De Pijp
Held Monday to Saturday on Albert Cuypstraat, this open-air market offers food from fresh fish to *stroopwafels*, as well as flowers, clothes and accessories.

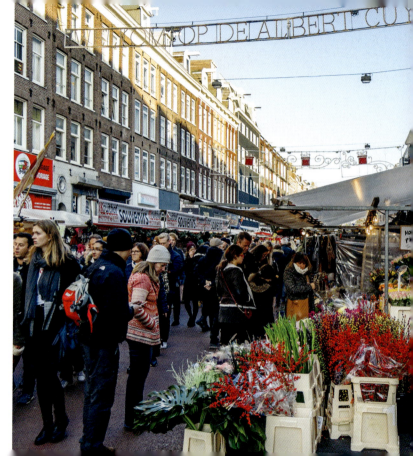

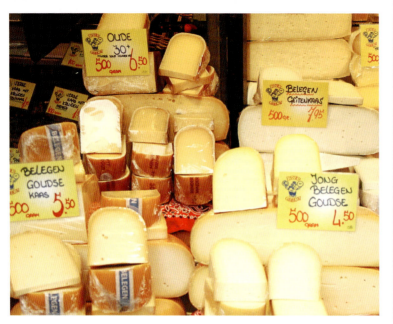

BOTH PHOTOGRAPHS:
Dappermarkt, Dapperbuurt
In the eastern district of Dapperbuurt, this streetmarket is popular with locals, who come to buy well-priced products ranging from Dutch cheese to African textiles.

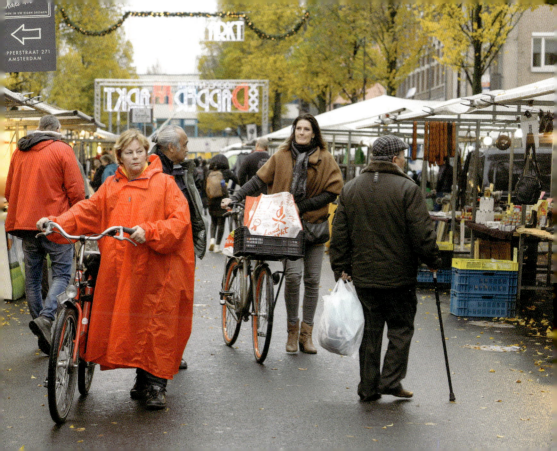

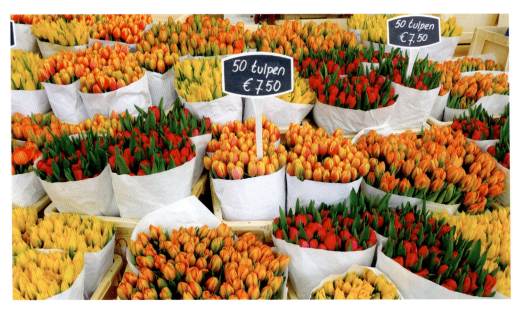

ABOVE:
Bloemenmarkt, Grachtengordel
The floating flower market is open to browsers and buyers on every day of the week. During the spring season, it sells a plethora of varieties of cut tulips. Bulbs are best bought between September and December.

OPPOSITE:
Spiegelstraat, Grachtengordel
The Spiegelkwartier is known for its antique shops, art galleries, vintage clothing and quirky curios. Pretty Spiegelstraat is named after the wealthy Spiegel family, who lived nearby in the 16th and 17th centuries.

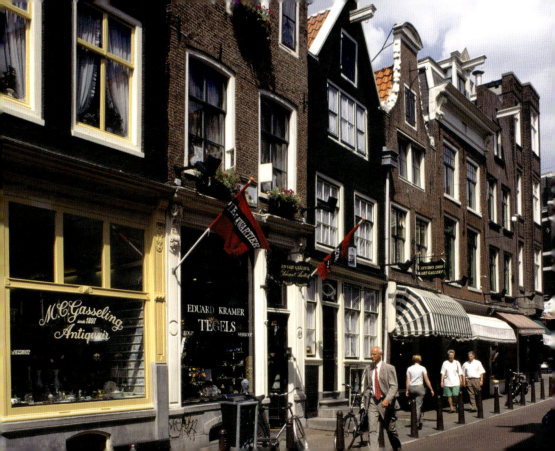

RIGHT:
Food Hallen, Kinkerbuurt
Located in a former tram depot, this food hall offers fare from Vietnamese rolls to Mumbai tikka wraps.

OPPOSITE LEFT:
Stamppot
Stamppot is a Dutch dish of potatoes mashed with vegetables and garnished with smoked sausage.

OPPOSITE RIGHT TOP:
Bitterballen
These breaded, fried meatballs are usually seasoned with nutmeg.

OPPOSITE RIGHT BOTTOM:
Tompouce
This iconic treat consists of two layers of puff pastry, sandwiching thick pastry cream and topped by orange or pink icing.

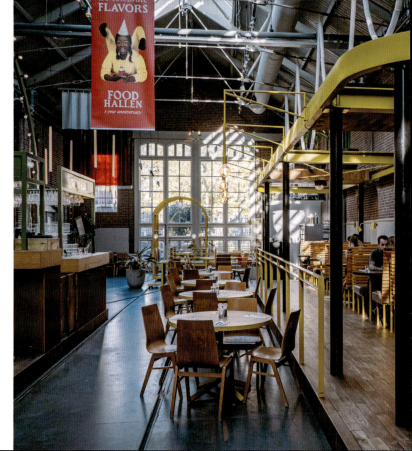

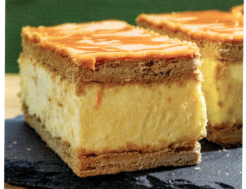

RIGHT:
Jenever
Brewed in Amsterdam and other Dutch cities, this juniper-flavoured spirit is traditionally served in tulip-shaped glasses. The jenever is poured to the brim, relying on surface tension to prevent spillage.

FAR RIGHT:
House of Bols, Oud-Zuid
The Bols family opened their first distillery in what is now Amsterdam's Jordaan neighbourhood in 1575. The family's very first product was jenever.

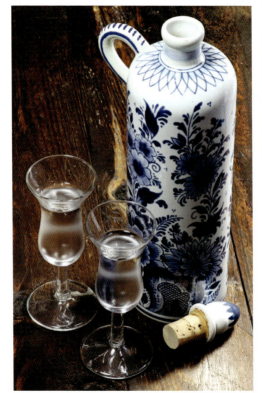

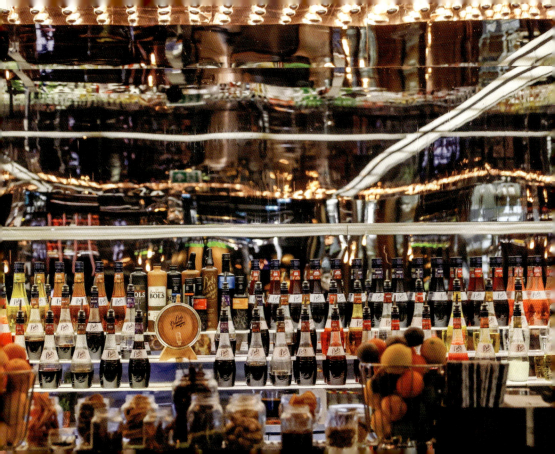

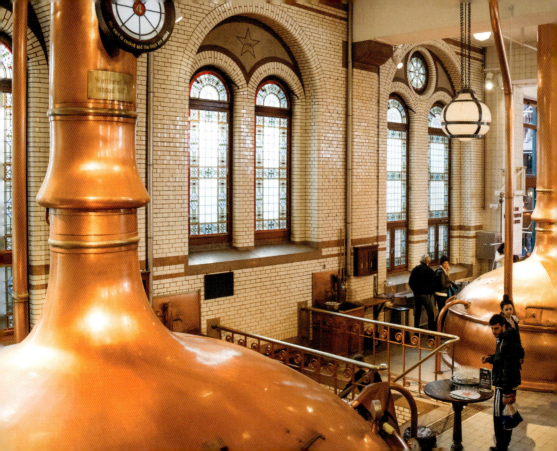

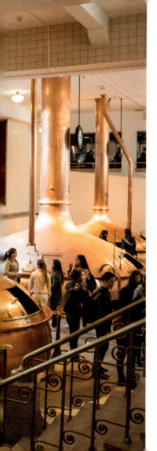

BOTH PHOTOGRAPHS:
Heineken Brewery, De Pijp
Built in 1867, this former brewery offers tours that take in the huge copper kettles, the stables and the ever-popular tasting room. The founder of the Heineken brand, Gerard Adriaan Heineken, bought his first brewery in 1864.

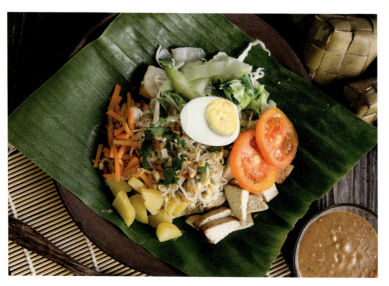

ABOVE:
Balinese Sate and Sambal
Thanks to the city's sizeable Indonesian community, Amsterdam is one of the best places outside Asia to sample Balinese food.

RIGHT:
Sea Palace, Oosterdok
This three-storey Chinese eatery is the largest floating restaurant in Europe. It offers Cantonese specialities including dim sum.

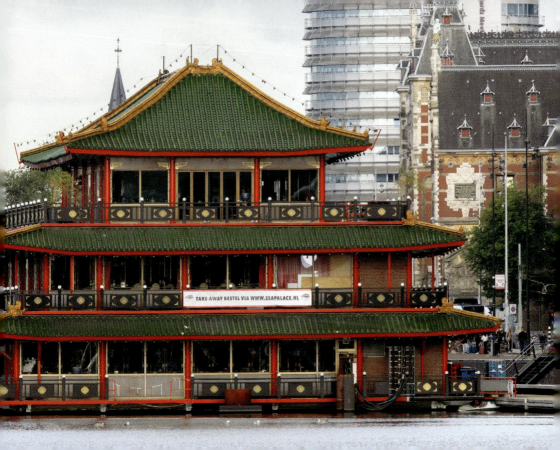

RIGHT:
Andaz Amsterdam Prinsengracht, Grachtengordel
Styled by Dutch designer Marcel Wanders, this hotel restaurant offers international cuisine. It is one of the city's over 1000 restaurants, which range from low-priced *eetcafés* to antique-filled inns.

OPPOSITE:
Pannenkoek
Amsterdam is famous for its pancakes, which are eaten for lunch, dinner or snacks. Toppings may be sweet (such as chocolate or apples) or savoury (such as bacon and Gouda).

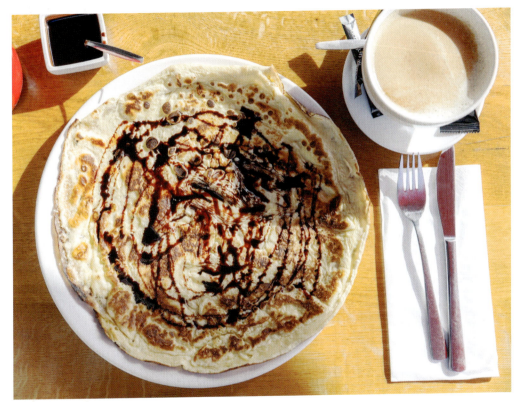

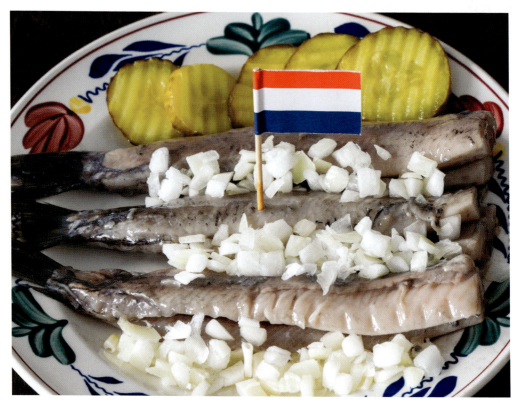

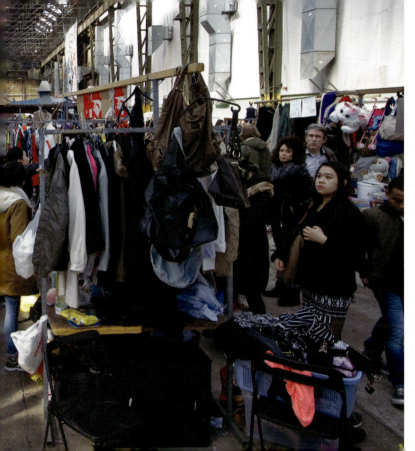

OPPOSITE:
Maatjes
Traditional soused herring is ripened in a saltwater-filled oak barrel for around five days. The snack is served with sliced raw onion and pickles, then eaten by tossing back the head and wolfing the whole fillet.

LEFT:
IJ-Hallen Flea Market, NDSM-Werf
With more than 700 stalls, this is the largest flea market in Europe. It is held on one weekend each month, in and around former warehouses on the north side of the IJ.

ALL PHOTOGRAPHS:
Stroopwafels
A *stroopwafel* consists of two thin, round wafers, held together by a syrup filling. The wafers are made from thick, sweet dough that is cooked in a waffle iron until crisp. The treats were probably first made in Gouda in the early 18th century.

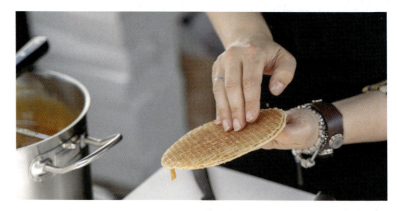

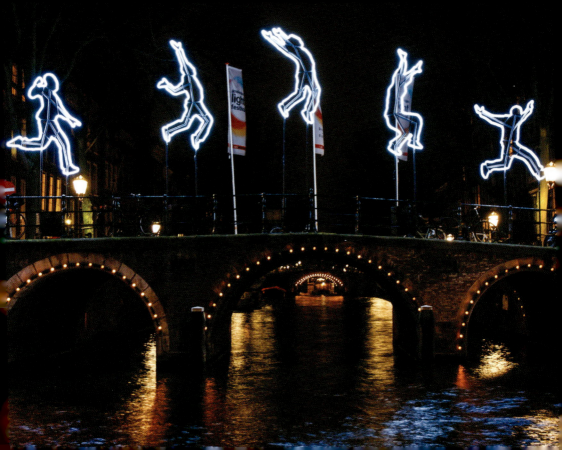

Entertainment & Nightlife

Amsterdam is famed for its nightlife, with countless visitors drawn to the city purely for its smoking coffeeshops and Red Light District, which are centred on the old city neighbourhood of De Wallen ('The Walls'). This district, once close to the medieval harbour and its sailors, gets its name from the walls that lined its canals. Both prostitution and cannabis are legal in Amsterdam within strictly policed parameters. The Red Light District's sex workers are tax payers with access to healthcare and legal support. The district's coffeeshops, which never serve alcohol, have been allowed to sell small quantities of cannabis since 1976. They can be recognized by their cannabis-leaf signage.

Another of Amsterdam's nightlife institutions is its brown cafés, which are clustered mainly in Jordaan and the old centre. These cosy, traditional bars get their name from their dark wood panelling and tobacco-stained walls. Smoking is no longer allowed, but the cafés still serve the staples of beer, jenever and *bitterballen*. Yet another Amsterdam institution is Paradiso, a music venue where acts from Bad Brains to Van der Graaf Generator have recorded live albums. Classical music and theatre performances are hosted nearby at venerable venues including the Koninklijk Theater Carré. Yet the biggest crowds of all flock to the Johan Cruyff Arena. Since 1996, it has been home to AFC Ajax and the host of UEFA Euro matches.

OPPOSITE:
Amsterdam Light Festival
From late November to mid-January, Amsterdam's canals, bridges and public buildings are lit up by the artists' installations of the Amsterdam Light Festival. Each year's festival has a theme, from rituals to AI.

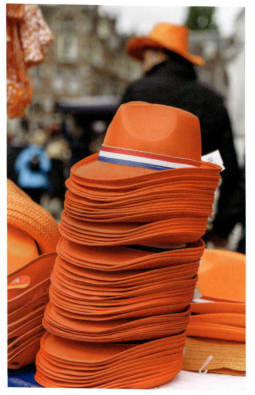
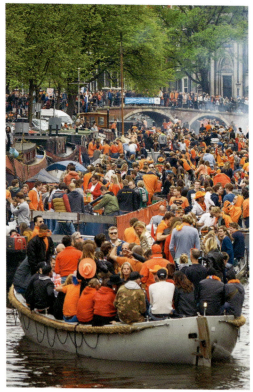

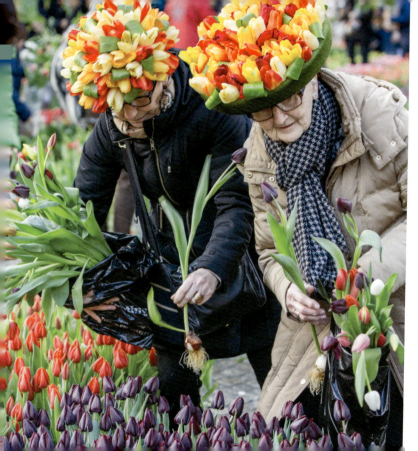

OPPOSITE LEFT AND RIGHT:
Koningsdag
Celebrated on 27 April, King's Day marks the birth of King Willem-Alexander. Amsterdam breaks into *oranjegekte* (orange fever), with people wearing clothes and eating food and drink in the traditional colour of the Dutch royal family.

LEFT:
Nationale Tulpendag
National Tulip Day is celebrated on the third Saturday in January to mark the start of the tulip season. Museumplein disappears under 200,000 tulips, which can be picked for free in the afternoon.

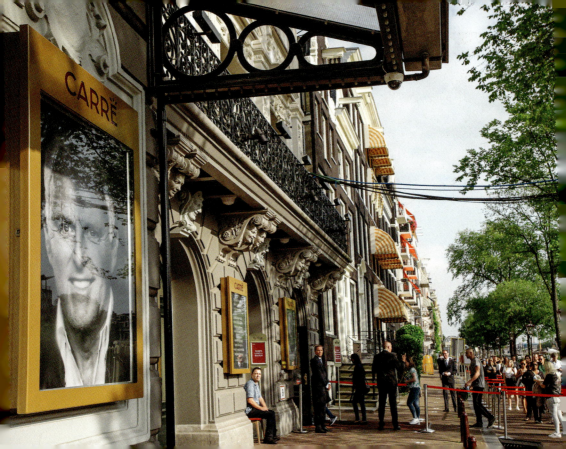

BOTH PHOTOGRAPHS:
Koninklijk Theater Carré, De Plantage
Built as a circus for impresario Oscar Carré in 1887, this Neoclassical building stages pop concerts, musicals, comedy and cabaret. The theatre has seen performances by Dutch legends Toon Hermans and Youp van 't Hek, as well as international names such as Kate Bush.

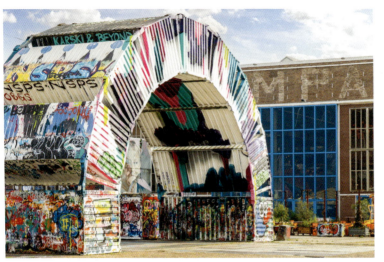

BOTH PHOTOGRAPHS:
NDSM-Werf
This former shipyard has sparked into a countercultural hotspot, with a steady supply of bars, restaurants and clubs, as well as a changing calendar of festivals, exhibitions and dance parties.

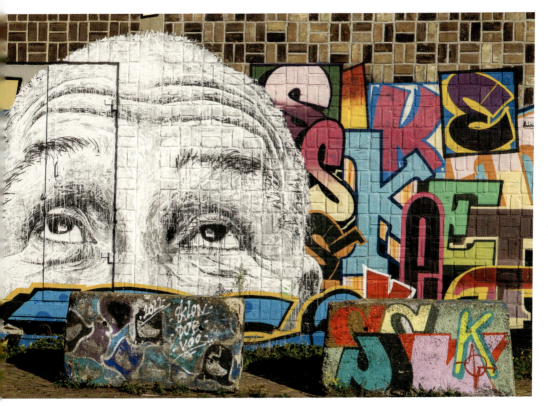

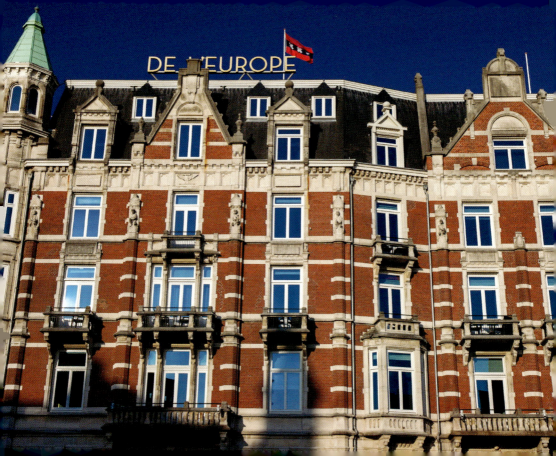

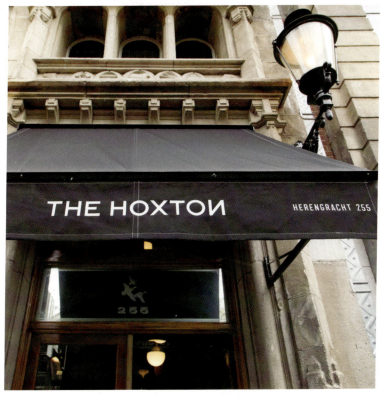

OPPOSITE:
De L'Europe, Centrum
On the bank of the Amstel, this neo-Renaissance hotel opened in 1896. The hotel's Freddy's Bar is named after Freddy Heineken, who was famously kidnapped in 1983.

LEFT:
The Hoxton, Grachtengordel
With views over the Herengracht and in easy reach of the Nine Streets shopping district, this fashionable hotel is in a 19th-century canal house.

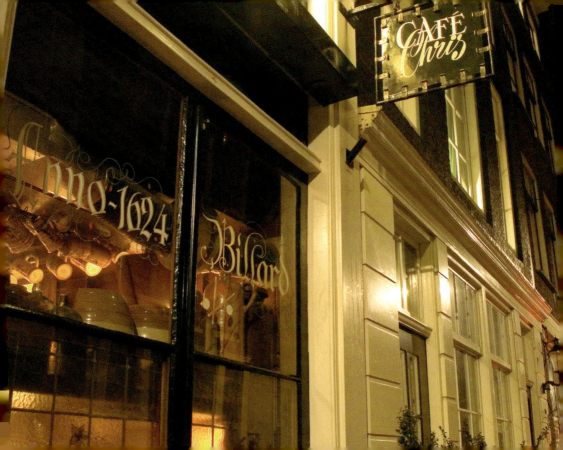

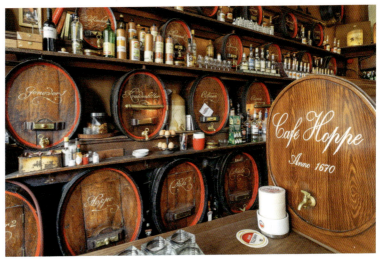

LEFT:
Café Chris, Jordaan
Opened in 1624, this brown café is the oldest in Jordaan. The cosy, wood-pannelled bar offers billiards and *bitterballen*.

ABOVE:
Café Hoppe, Centrum
Lined with old jenever barrels, Café Hoppe has been a fixture since 1670. The bar is usually so full it spreads onto the Spui.

OVERLEAF:
Olympisch Stadion, Oud-Zuid
Built for the 1928 Olympics, this brick stadium is a masterpiece of the Amsterdam School.

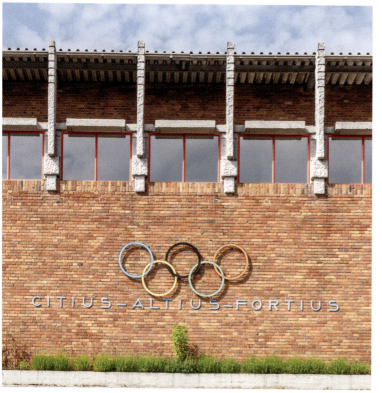
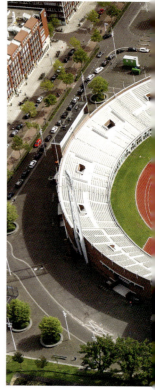

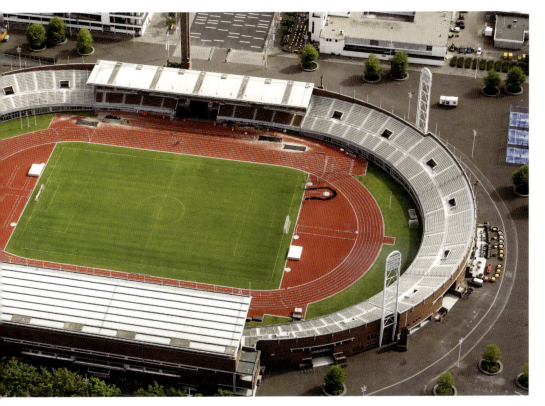

Korte Leidsedwarsstraat, Leidseplein

Just beyond the canal belt, between Prinsengracht and Singelgracht, is the nightlife hub of the Leidseplein neighbourhood. Locals and tourists flock to the many restaurants, bars, coffeeshops and clubs.

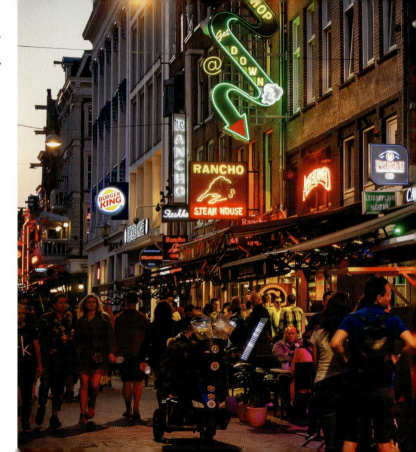

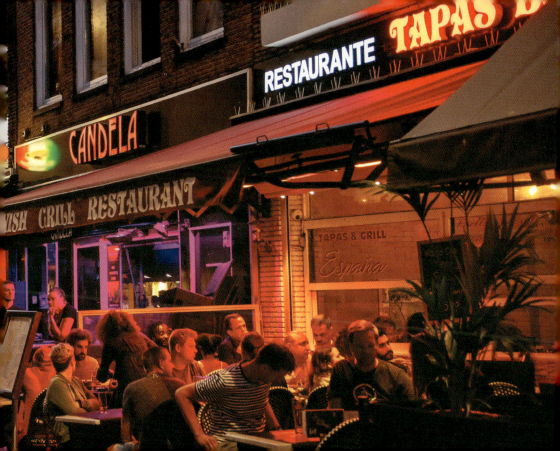

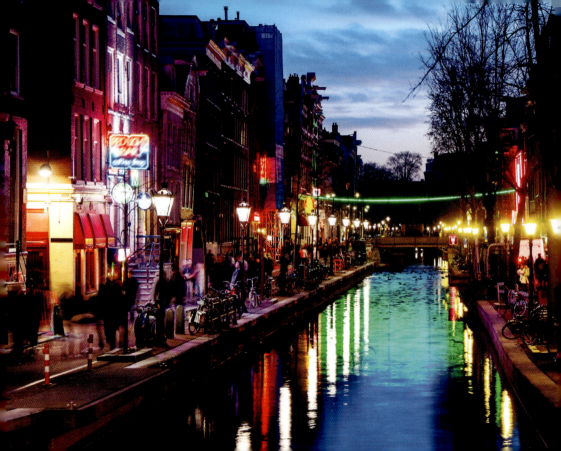

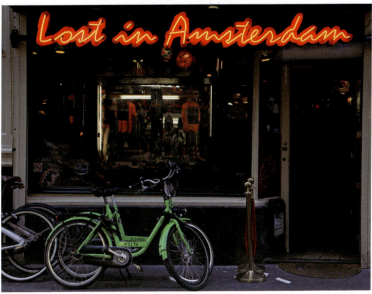

LEFT:
De Wallen
Oudezijds Achterburgwal is at the heart of the Red Light District, known for its brothels, sex shops and cannabis coffeeshops.

ABOVE:
Lost in Amsterdam, Centrum
One of the first smoking lounges, this coffeeshop is a place to smoke cannabis and buy milkshakes.

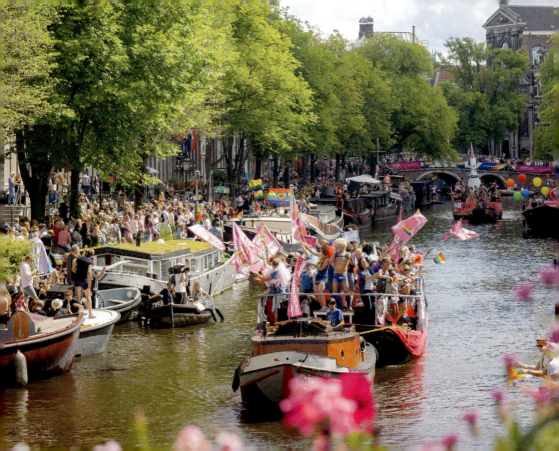

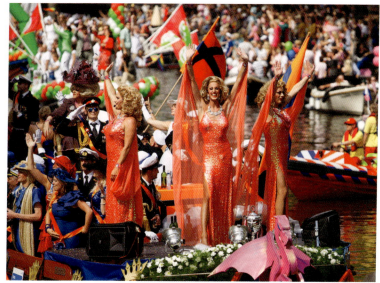

BOTH PHOTOGRAPHS:
Amsterdam Pride
Held on the first weekend in August, the city's LGBTQ+ festival was first celebrated in 1996. During the Canal Parade, participants' boats sail from Westerdok, down the Prinsengracht, Amstel, Zwanenburgwal and Oudeschans to Oosterdok.

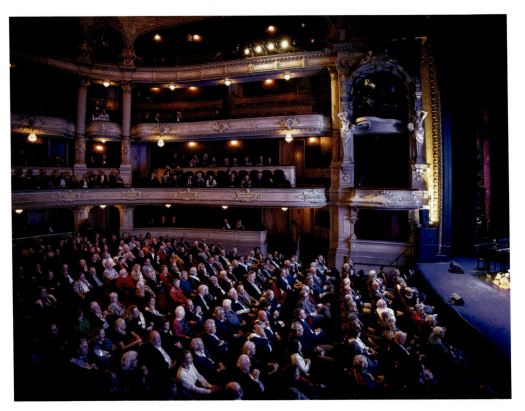

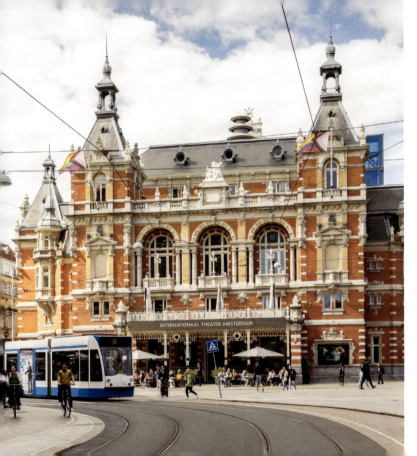

BOTH PHOTOGRAPHS:
Stadsschouwburg, Leidseplein
Built in 1894 to a design by Jan Springer, this delicately ornamented neo-Renaissance theatre offers a vibrant programme of drama, dance and musical theatre.

Johan Cruyff Arena, Zuidoost

Completed in 1996, the Netherlands' largest stadium has a capacity of 55,865 during football matches. In 2018, the stadium was renamed in honour of football legend Johan Cruyff, who died in 2016.

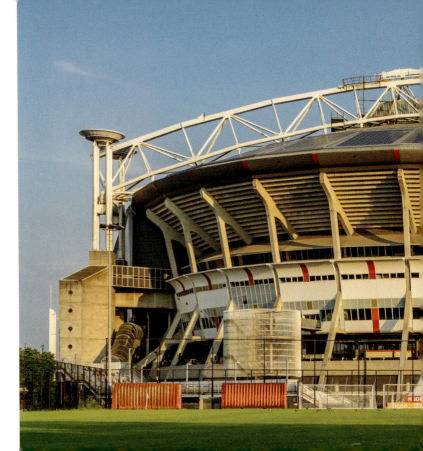

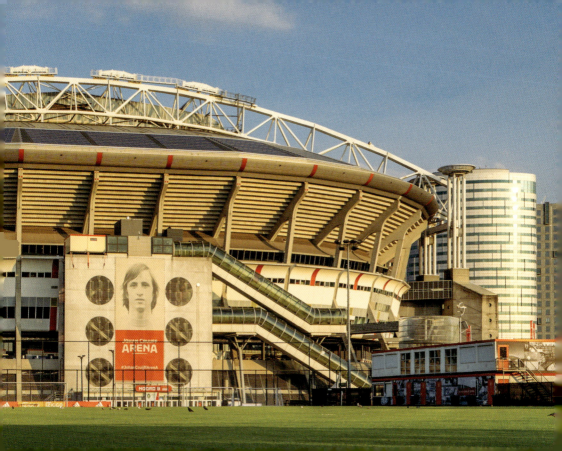

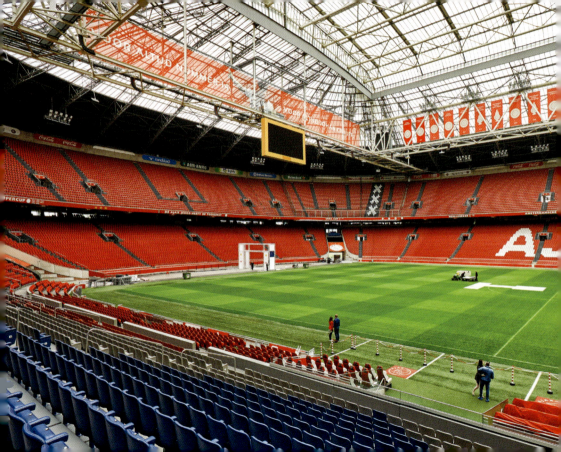

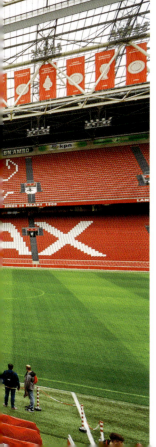
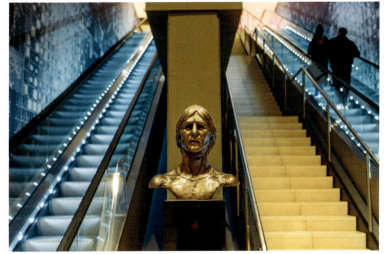

BOTH PHOTOGRAPHS:
Johan Cruyff Arena, Zuidoost
This retractable-roofed stadium is home to AFC Ajax, for whom Johan Cruyff played between 1957 and 1973 and again from 1981 to 1983. Cruyff returned as manager for three years from 1985.

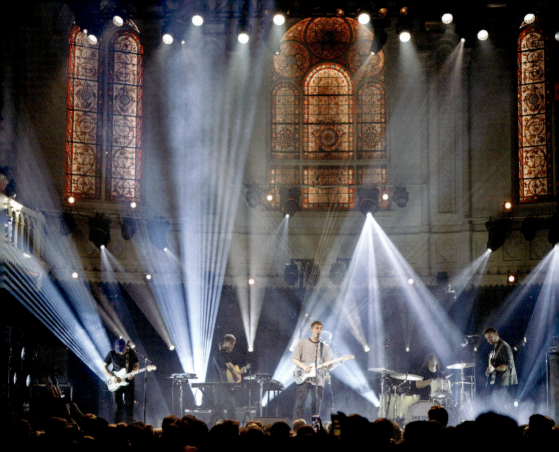

BOTH PHOTOGRAPHS:
Paradiso, Leidseplein
This world-famous music venue is housed in a 19th-century meeting place for the Vrije Gemeente (Free Congregation) religious community. The Rolling Stones, Prince, David Bowie and Nirvana are just some of the international acts that have played here.

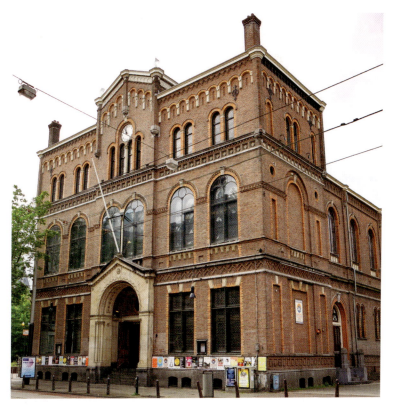

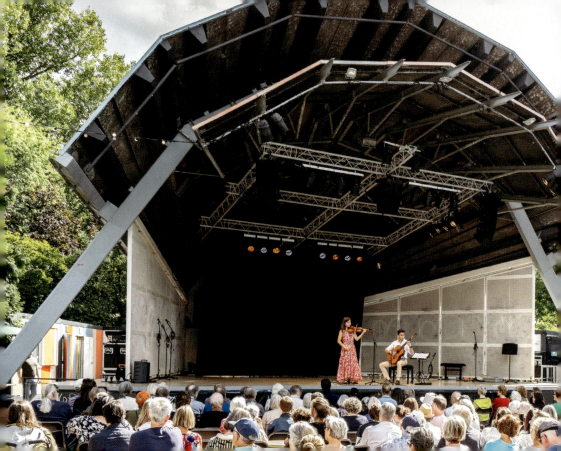

Vondelpark Openluchttheater, Oud-Zuid

From May to September, this open-air theatre in the pretty Vondelpark offers a programme of free concerts, children's shows and comedy.

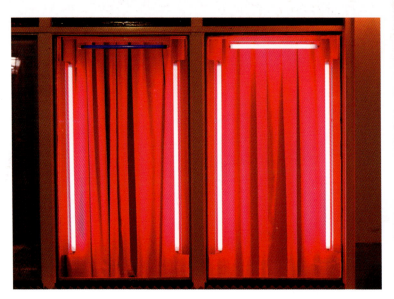
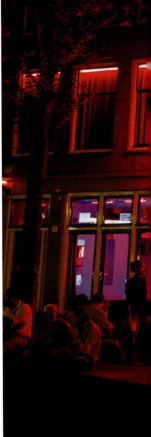

BOTH PHOTOGRAPHS:
De Wallen
The Rossebuurt (Red Neighbourhood) has been known for its sex workers since medieval times. Window prostitution, in which a worker rents a window and workspace, is legal in Amsterdam. A red light indicates that a cis woman is working, while blue is used by transgender women.

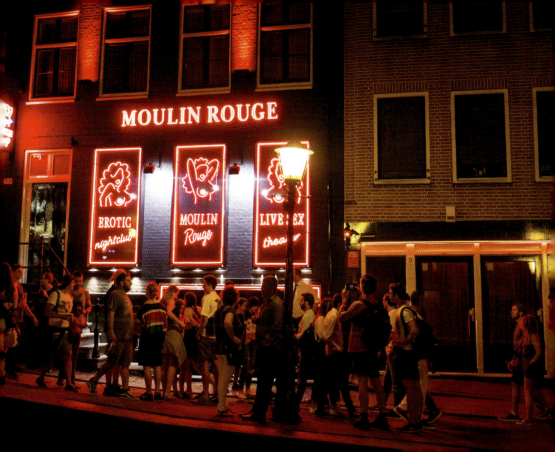

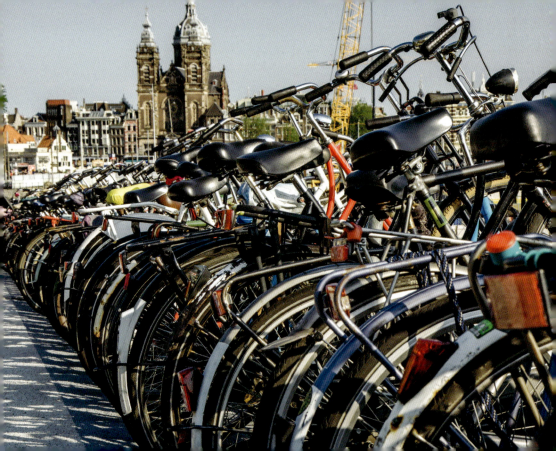

Transport

Amsterdam has more than 150 canals, which split the city into around 90 islands, linked by over 1200 bridges. During the Golden Age and for centuries later, Amsterdam's canals and the Amstel River were its main transportation routes, but today these narrow waterways are used mostly by pleasure craft, tour boats and the occasional parcel boat or water taxi. Now nearly two-fifths of Amsterdam's daily journeys are made by bicycle, creating a problem unknown in most cities: cycle congestion. Only one-fifth of the city's daily journeys are made by car. In fact, the city authorities aim to turn Amsterdam into a car-free zone by making car travel as awkward and unnecessary as possible. The city centre offers disorientatingly complex one-way systems and countless pedestrian streets, as well as few and exorbitant parking spaces. The carrot counterpart to this stick is Amsterdam's wide, speedy and low-cost public transport system, which includes buses, trams and five metro lines, the first of which opened in 1977. Ferries across the IJ are unaccountably free. Yet, for most visitors, walking is the ideal way to experience Amsterdam's central neighbourhoods, including the old town, Grachtengordel and Jordaan districts. Not only are the distances relatively short, but strolling gives the time to admire gables, spires, statues, shopfronts and the picture-perfect canal vistas that appear around every corner.

OPPOSITE:
Bike Park, Centraal Station
Amsterdam has around 900,000 privately owned bicycles, giving it slightly more bikes than people. Since 2023, the largest bicycle park has been Stationsplein's underwater garage, which has room for 7000 bikes.

BOTH PHOTOGRAPHS AND OVERLEAF:
Cycling
With 400 km (250 miles) of cycle paths, flat terrain and a city centre that is barely navigable by car, bike is the most popular way to travel in Amsterdam. Dedicated cycle paths are red to differentiate them from footpaths and roads.

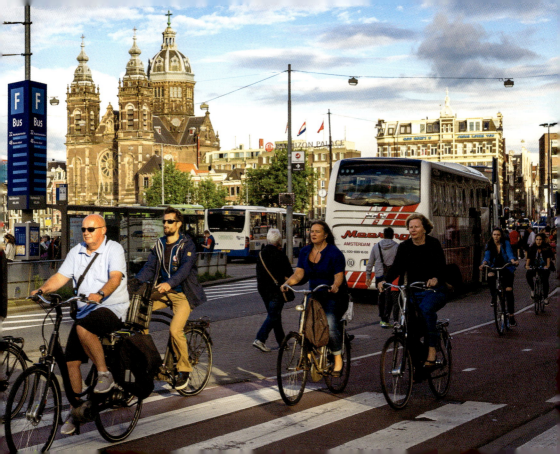

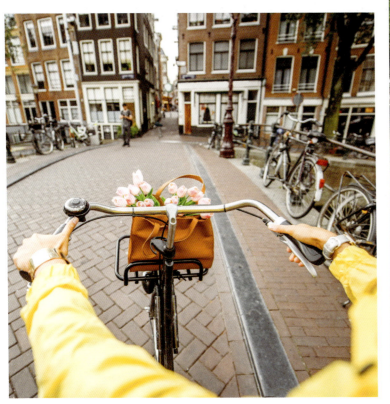

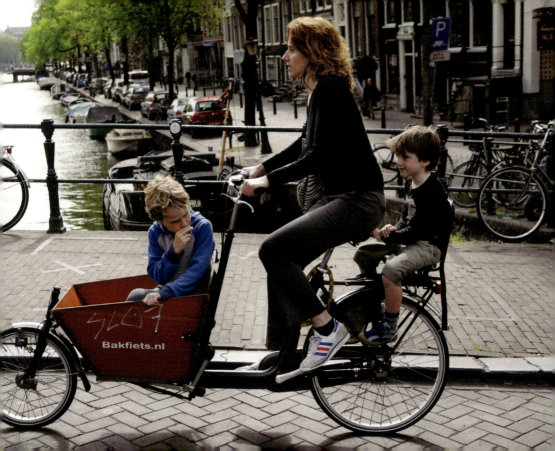

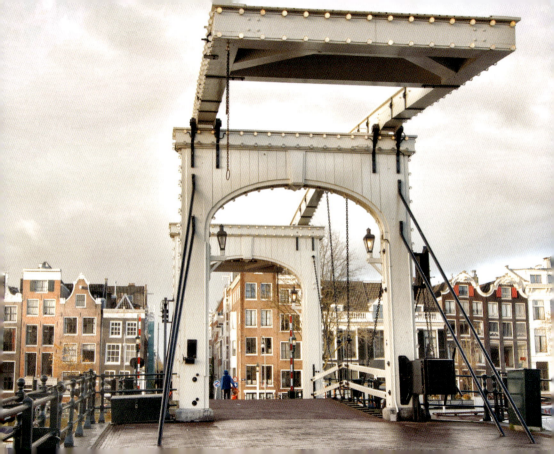

OPPOSITE:
Magere Brug, Grachtengordel
The 'Skinny Bridge' crosses the Amstel at Kerkstraat. The current wooden bridge, used only by pedestrians and cyclists, was built in 1934. It is opened several times a day for river traffic.

LEFT:
Blauwbrug, Grachtengordel
Crossing the Amstel 200 m (650 ft) north of the Magere Brug, this 1883 stone bridge was inspired by ornate Beaux-Arts bridges across Paris's River Seine.

BOTH PHOTOGRAPHS:
Tram
The Amsterdam tram network consists of 14 lines and 500 stops. The system dates back to 1875, when the first horse-drawn trams went into operation. Today, the trams are powered by electricity from sustainable sources.

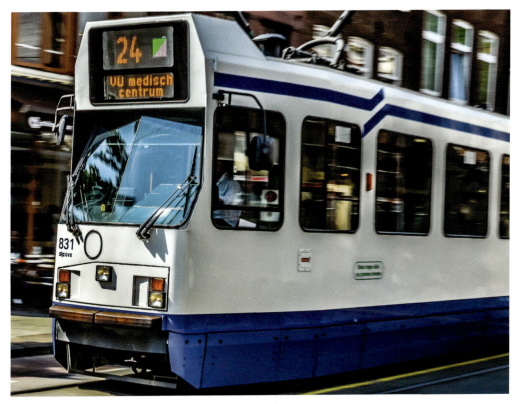

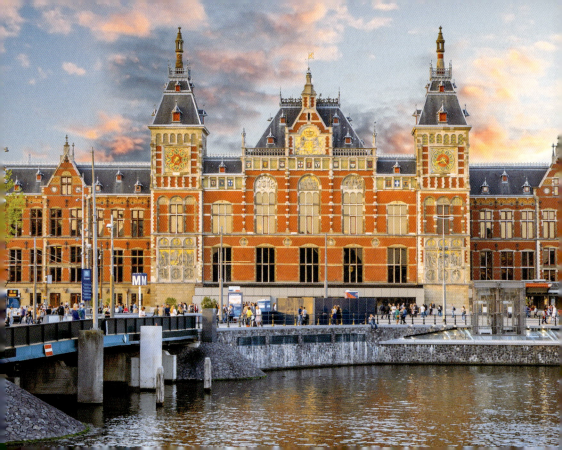

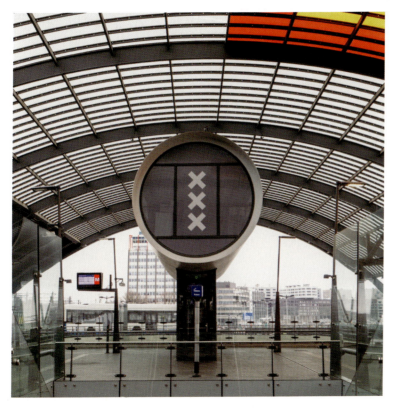

BOTH PHOTOGRAPHS:
Centraal Station, Waterfront
This station is a hub for national and international trains, as well as Metro, tram, ferry and bus routes. The main building was designed by ubiquitous architect Pierre Cuypers and opened in 1889.

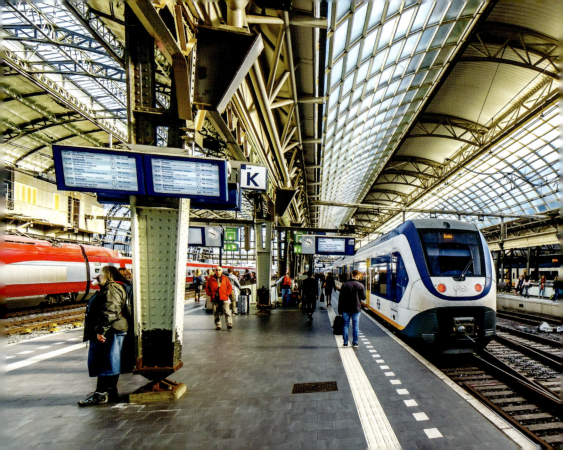

Centraal Station, Waterfront

Used by more than 190,000 passengers daily, Centraal Station is the Netherlands' second busiest train station after Utrecht Centraal. All the platforms are covered by curving cast-iron roofs, which are playfully reflected in the roof of the 2015 bus station (see previous page).

ABOVE:
Taxi
Although it is possible to hail a cab, those with tired legs are more likely to get a ride by using an app or finding a rank in squares such as Rembrandtplein and Leidseplein.

OPPOSITE:
Solar Rickshaw
Powered more by legs than by sunlight, this solar rickshaw is one of Amsterdam's many planet-friendly transport options.

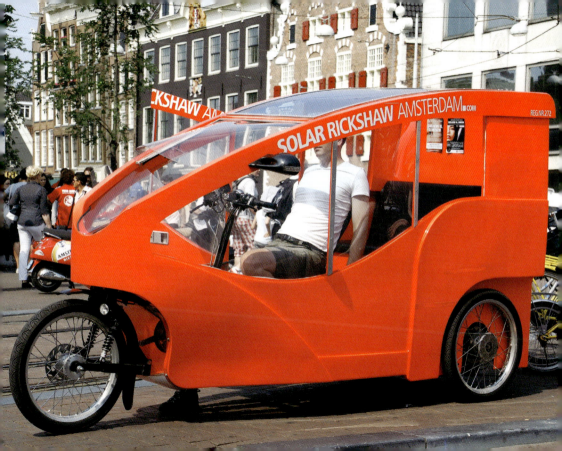

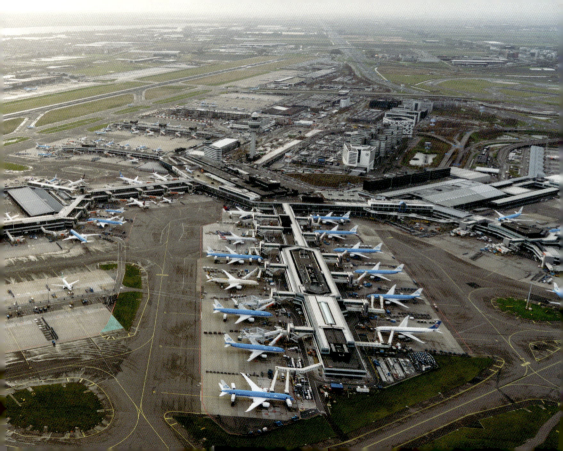

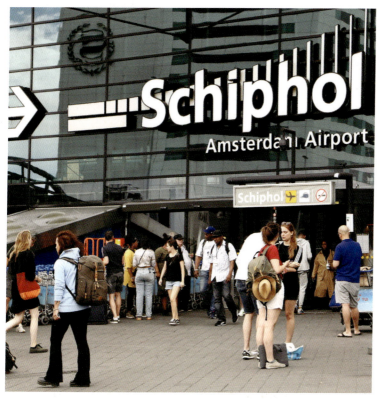

BOTH PHOTOGRAPHS:
Schiphol Airport
Around 9 km (6 miles) southwest of Amsterdam, and 15 minutes by train from Centraal Station, Schiphol is Europe's fourth busiest airport, after London Heathrow, Istanbul and Paris Charles de Gaulle. Schiphol sees more than 60 million passengers each year.

RIGHT:
Station Noord, Buikslotermeer
Amsterdam Metro's North–South line opened in 2018, with Noord the northernmost station on the city outskirts. The station's floor tiles feature an artwork of maps and birds by Harmen Liemburg.

OPPOSITE:
Centraal Station Metro Hall, Waterfront
Nicknamed 'the Cathedral' for its high, ribbed ceiling and soaring pillars, the hall of the North–South Metro line is 15 m (49 ft) below the water level of the IJ.

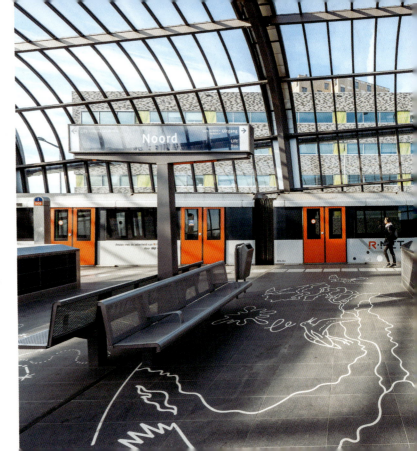

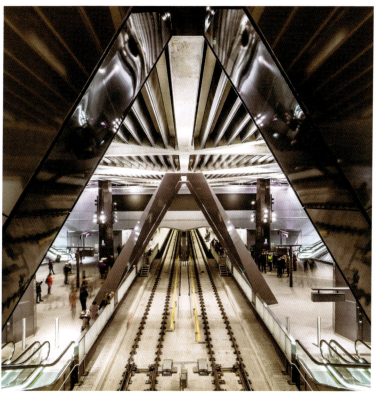

211

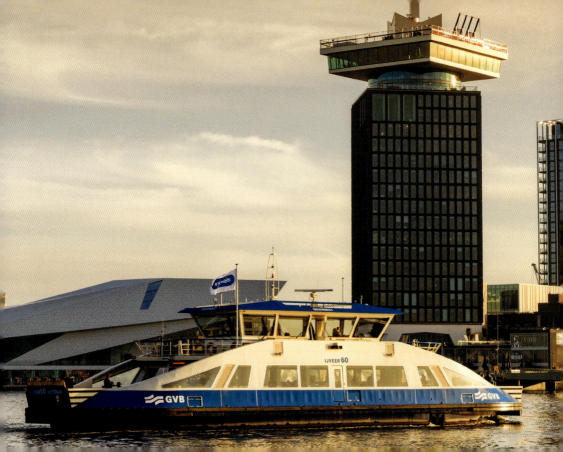

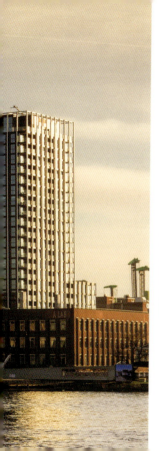
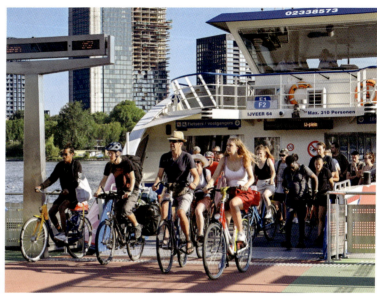

BOTH PHOTOGRAPHS:
IJ Ferries
Every few minutes, ferries carry pedestrians, cyclists and mopeds across the IJ to Amsterdam Noord. From Centraal Station, there are ferries to IJplein, Buiksloterweg and NDSM-Werf.

Canal Cruise
Low-slung tourist boats ply the canals of the Grachtengordel, giving visitors the same perspective of canal houses and churches as was glimpsed by merchants and dockworkers of the Golden Age.

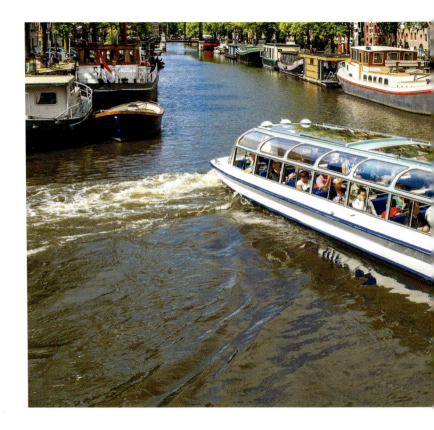

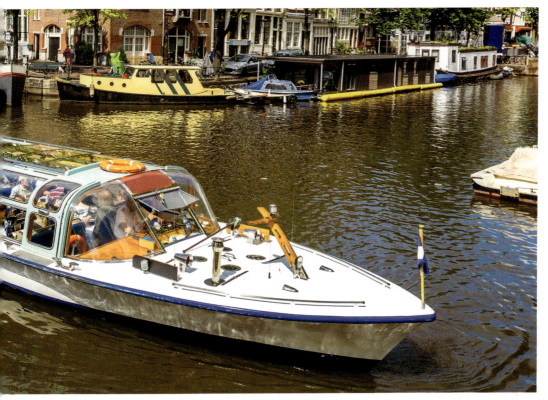

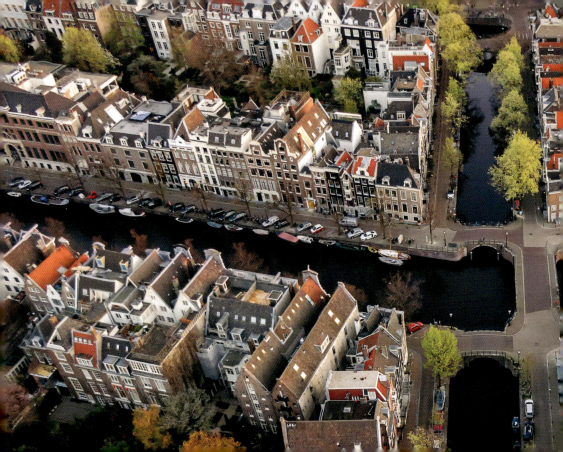

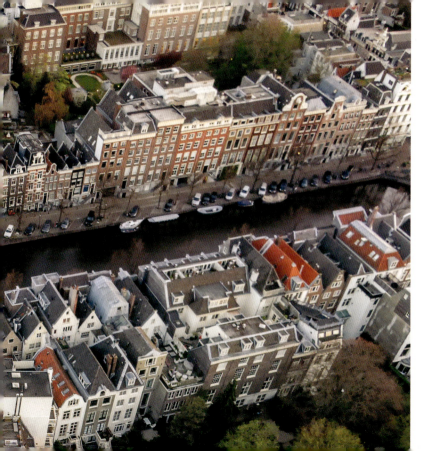

Grachtengordel

Amsterdam has more than 100 km (62 miles) of canals. Three of the four concentric canals of the Grachtengordel – the Herengracht, Keizersgracht and Prinsengracht – were dug to around 2.5 m (8 ft) in the early 17th century to help transport goods. The fourth canal, the Singel, already served as a moat for the medieval city.

217

ABOVE:

Brouwersgracht, Jordaan
Lined with shuttered warehouses that have been converted into apartments, this canal was named for its breweries.

RIGHT:

Vier Heemskinderenbrug, Grachtengordel
This three-arched bridge crosses Leidsegracht on the western quay of the Herengracht.

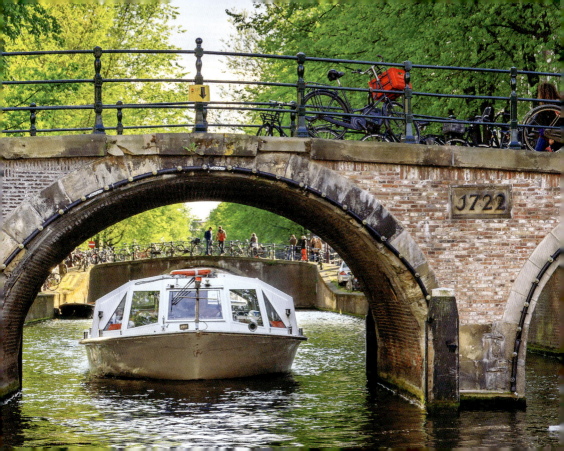

BOTH PHOTOGRAPHS:
Houseboats
Most of Amsterdam's 2400 houseboats have a permanent mooring and lack a motor for travelling from place to place. While some are converted barges that were once itinerant, others are shipping container-like structures that were built on a floating pontoon.

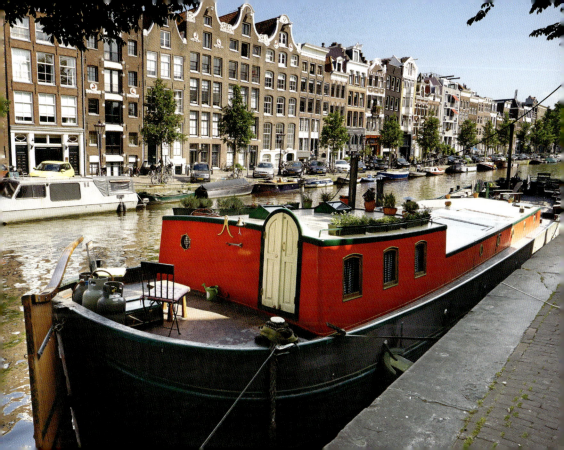

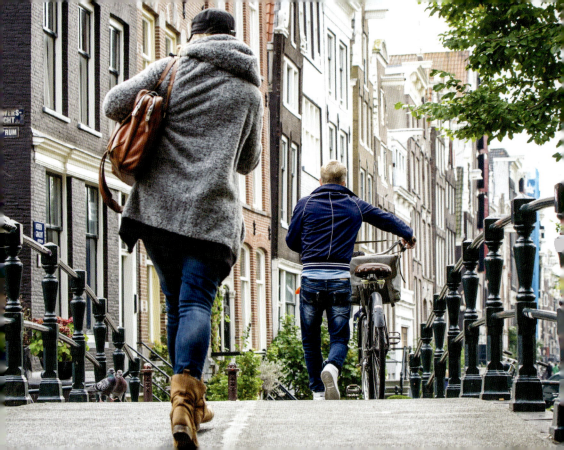

BOTH PHOTOGRAPHS:
On Foot
In most cities, pedestrians must stay acutely aware of cars, but in Amsterdam it is trams and speeding bikes that pose the greatest risks to unwary walkers. It is best to remember that trams and bikes have right of way.

Picture Credits

Alamy: 7 (Berk Ozdemir), 8 (Wim Wiskerke), 12 (Cyrille Gibot), 14 (Urbanmyth), 15 (Hugo Kurk), 16 (David Gee), 17 (Simon Montgomery), 26 (Pixelstock), 31 (Hemis), 34 (eye35), 42 (David Gee), 43 (imageBroker), 51 (Wiskerke), 52 (robertharding), 53 bottom (Digital-Fotofusion Gallery), 61 (Artshotphoto), 69 (Digital-Fotofusion Gallery), 82 (Associated Press), 83 (Edwin Remsberg), 84 (World History Archive), 85 (Jorge Royan), 91 (George Oze), 94 (Jochen Tack), 95 (Jussi Puikkonen), 100 (Peter van Evert), 107 (Noppasin Wongchum), 109 (Hemis), 111 (Terence Waeland), 114 (Russell Hart), 121 (imageBroker), 126 (UrbanImages), 127 (picturelibrary), 138 (Image Professionals GmbH), 143 (Whittaker Geo), 145 (Peter Horree), 155 (Westend61 GmbH), 157 (Paolo Giannotti), 163 (frans lemmens), 164 (SOPA Images Limited), 165 (ANP), 169 (Stuart Forster), 170 (Alberto Paredes), 171 (imageBroker), 180 (ANP), 186 (dpa picture alliance), 221 (Jan Wlodarczyk)

Dreamstime: 6 (Olgacov), 13 (Marcel van den Bos), 22/23 (Avantgardx), 24 (Christophecappelli), 28/29 (Hpbfotos), 32/33 (Olgacov), 37 (Ingehogenbijl), 38 (Andrewbalcombe), 39 (MartinBergsma), 46/47 (Tupungato), 48 top (Elifranssens), 49 (Izibns), 53 top (Jamesandrews29), 57 (Felker), 58 (Jonkio4), 65 (Tupungato), 75 (Sjankauskas), 78 (Garrett1984), 80 (Xavierallard), 81 (Marcellocelli), 89 (22tomtom), 92 (Wjarek), 96 (Atosan), 97 (Jorisvo), 98/99 (Bloodua), 101 (Irinasafronova), 102/103 (Hpbfotos), 106 (Karaul), 110 (Eugenesergeev), 119 (Prescott09), 120 (AlizadaStudios), 124 (Xavierallard), 125 (GateGallery), 140 (Valilung), 148 (Bjoern Wylezich), 161 (Digikhmer), 167 (Casperdedroog), 182/183 (Avantgardx), 187 (Kutredrig), 198 (Varandah), 200 (Chrisdodutch), 204/205 (Hpbfotos), 210/211 (Davidpeperkamp), 211 (Rollemaphotography), 212 (Taratata)

Shutterstock: 10/11 (Martin Bergsma), 18 (Marcel van den Bos), 19 (Simlinger), 20/21 (Protasov An), 25 (Christophe Cappelli), 27 (Smeerjewegproducties), 30 (S. Vincent), 35 (Tupungato), 36 (Martyn Jandula), 40 (Anton Mezinov), 41 (Rostislav Glinsky), 44/45 (Rudmer Zwerver), 47 right (John Selway), 48 bottom (Solomon Rost), 50 (Bert e Boer), 54 (simona flamigni), 55 (Claudine Van Massenhove), 56 (Anibal Trejo), 59 (photosmatic), 60 (Victor Maschek), 62 (Adisa), 63 (Pavlo Glazkov), 64 (Dutchmen Photography), 66/67 (Milos Ruzicka), 68 (Alexey Fedorenko), 70 (Alexander Tolstykh), 71 (Fabrizio Guarisco), 72/73 (PixelBiss), 74 (Martijn Alderse Baas), 76 (Boris Stroujko), 77 (Sina Ettmer Photography), 86 (Kurka Geza Corey), 87 (Konstantin Tronin), 88 (Emzzi), 90 (Kiev Victor), 93 (ColorMaker), 103 right (Harry Beugelink), 104 (Fortgens Photography), 105 (Milos Ruzicka), 108 (Dutchmen Photography), 112 (theendup), 113 (Dutchmen Photography), 115 (Neirfy), 116 (TTstudio), 117 (Kit Leong), 118 (jeafish Ping), 122 (Wut Moppie), 123 (Harry Beugelink), 128 (Marc Bruxelle), 129 (Konstantin Tronin), 130 (Wut Moppie), 132 (Peeradontax), 133 (KievVictor), 134/135 (Harry Beugelink), 136 (KievVictor), 137 (Harry Beugelink), 139 (Procreators), 141 (Martien van Gaalen), 142 (simona flamigni), 144 (Mario Savoia), 146 (fokke baarssen), 147 left (StockphotoVideo), 147 top (DronG), 147 bottom (barmalini), 149 (Todamo), 150 (Nicole Kwiatkowski), 151 (Wut Moppie), 152 (Odua Images), 153 (Dutchmen Photography), 154 (ariadna de raadt), 156 (Milos Ruzicka), 158 top (ENeems), 158 bottom (Eric Skadson), 159 (Dutchmen Photography), 162 left (hurricanehank), 162 right (Vladimir Zhoga), 166 (Wolf photography), 167 (Anamaria Mejia), 172 (Erik Laan), 173 (Aerovista Luchtfotografie), 174/175 (Ververidis Vasilis), 176 (Madrugada Verde), 177 (InnaFelker), 178 (Wut Moppie), 179 (Worldpics), 181 (Wolf photography), 184 (Vladimir Zhoga), 185 (Simlinger), 188/189 (Wolf-photography), 190 (charnsitr), 191 (4kclips), 192 (UA-pro), 194 (Timur Kulgarin), 195 (Sergii Figurnyi), 196 (RossHelen), 197 (Bumble Dee), 199 (tolobalaguer.com), 201 (Miguel MC), 202 (Olena Z), 203 (Francisco Duarte Mendes), 206 (4kclips), 207 (Claudio Caridi), 208 (Aerovista Luchtfotografie), 209 (Nancy Beijcrsbergen), 213 (Ceri Breeze), 214/215 (Sergii Figurnyi), 216/217 (Donaldb), 218 (Artur Bogacki), 219 (Dennis van de Water), 220 (Ackab Photography), 222 (Reggie Lee), 223 (timsimages.uk)